1990

VISIONS OF ILLINOIS

A series of publications portraying the rich heritage
of the state through historical and contemporary works
of photography and art

*A list of books in the series appears
at the end of this volume.*

PUBLISHED IN COOPERATION WITH THE JANE ADDAMS' HULL-HOUSE MUSEUM AT THE UNIVERSITY OF ILLINOIS AT CHICAGO

THE MANY FACES OF HULL-HOUSE

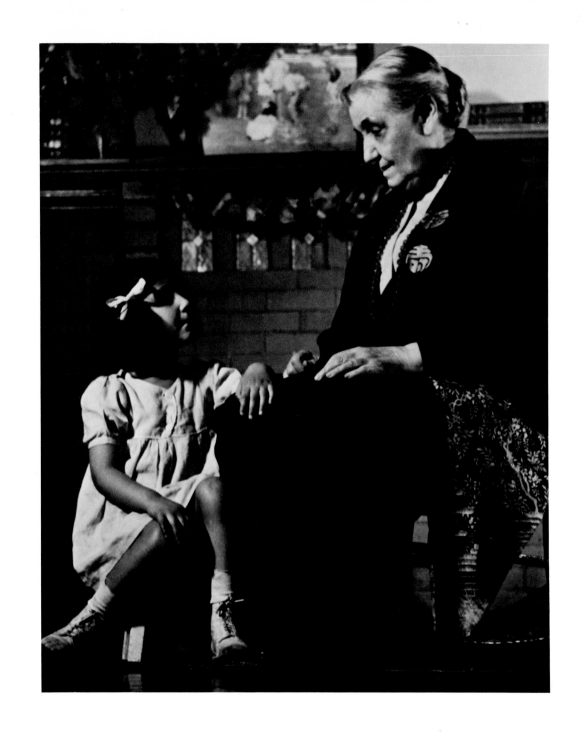

THE MANY FACES OF HULL-HOUSE

THE PHOTOGRAPHS OF WALLACE KIRKLAND / EDITED BY MARY ANN JOHNSON

UNIVERSITY OF ILLINOIS PRESS URBANA AND CHICAGO

The Wallace Kirkland photographs are part of the
Jane Addams' Memorial Collection in the University Library
of the University of Illinois at Chicago.

© 1989 by the Board of Trustees of the University of Illinois
Manufactured in the United States of America

1 2 3 4 5 C P 5 4 3 2 1

This book is printed on acid-free paper.

Library of Congress Cataloging-in-Publication Data

Kirkland, Wallace.
 The many faces of Hull-House : the photographs of Wallace Kirkland /
 edited by Mary Ann Johnson.
 p. cm.—(Visions of Illinois)
 "The Wallace Kirkland photographs are part of the Jane Addams
 memorial collection in the University Library of the University of
 Illinois at Chicago."—T.p. verso.
 ISBN 0-252-01683-1 (cloth). ISBN 0-252-06108-X (paper)
 1. Hull House (Chicago, Ill.)—Pictorial works. I. Johnson, Mary
 Ann. II. Title. III. Series.
 HV4196.C4K57 1989
 362.84'009773'11—dc20 89-32709
 CIP

To my mother and father,

who together taught me what education is

in its broadest sense

INTRODUCTION

When Wallace Kirkland arrived at Hull-House in 1922, the social settlement on Chicago's Near West Side was already a well-established institution. Founded on September 18, 1889, by Jane Addams and Ellen Gates Starr in an old mansion on Chicago's South Halsted Street, by 1910 Hull-House had grown into an imposing complex of thirteen buildings that covered nearly a city block. Activities for people of the surrounding immigrant neighborhood, initiated at Hull-House as tentative experiments during its first decade, had expanded by the 1920s into fully developed, complex programs, each with its own staff of experienced leaders and, in most cases, well-articulated philosophies. At this point, it was estimated that more than 9,000 people came weekly to Hull-House to participate in its many activities.

The residential staff at Hull-House in the 1920s numbered about sixty-five people, fifteen of whom had lived and worked at the settlement for at least twenty years. "Hull-House residents came from many walks of life," Kirkland noted in an unpublished memoir. "They were people who worked in other parts of the city, who wanted to live and share their talents with the less fortunate people of the neighborhood. They were doctors, lawyers, college professors, school teachers, social workers, students, musicians, actors, writers, poets, artists, politicians. Some lived in single rooms, others in apartments." Among those who provided continuity for Hull-House programs and set the standards of excellence to which others aspired were: Eleanor Smith, founder and director of the Hull-House Music School; Enella

Benedict, founder and director of the Art School; Norah Hamilton, director of children's art classes; Edith de Nancrede, director of junior dramatics and dancing; Laura Dainty Pelham, director of the Hull-House Players, a theater group; James Sylvester, director of the Boys' Band; Jessie Binford, director of the Juvenile Protective Association; Dr. Alice Hamilton, pioneer in industrial medicine; and, of course, Jane Addams and Ellen Gates Starr.

The 1920s also saw an influx of newcomers who contributed significantly to the vitality of Hull-House. Talented young artists like Morris Topschevsky, William Jacobs, Leon Garland, Sadie Ellis Garland, and Michael Gamboni formed an experimental artists' community, using the studios and shops of Hull-House for their own work while teaching art classes for people from the neighborhood. Other new residents maintained ties to Chicago institutions while volunteering at Hull-House: Myrtle French, who established and helped run the Hull-House Kilns while head of the ceramics department at the Art Institute; Robert Morss Lovett, professor of English at the University of Chicago and editor of the *New Republic*, and his wife, Ida. Many young residents with special training in social work, education, and other fields also joined the Hull-House community of teachers at this time.

The neighborhood that surrounded Hull-House in the early 1920s was, as it had always been, a point of entry for immigrants to the city. During the settlement's first decade, the major ethnic groups in the neighborhood had been the Irish, Germans, and Bohemians, with Italians, Jews from southern and eastern Europe, and Greeks just beginning to establish themselves. By the 1920s, the older immigrant groups had moved on to other parts of Chicago, bequeathing the neighborhood to the Italians, who lived in great numbers to the east and west of Hull-House, the Greeks, whose community stretched to the north, and some Jews still living in the old Maxwell Street area south of the settlement. Newcomers at this point were the Mexicans, who started arriving in great numbers, especially after the United States quota laws restricting immigration from eastern and southern Europe were instituted.

The Italian, Jewish, and Greek children who came to Hull-House in the 1920s were, for

the most part, second-generation immigrants, often highly motivated and responsive to the intellectual, social, and artistic opportunities offered by the settlement. Many of these young people were deeply influenced by their experiences, going on to become professional musicians, artists, writers, dramatists, social workers, and educators. Two notable examples are jazz greats Benny Goodman and Art Hodes, both of whom studied music at Hull-House—Hodes in the Music School and Goodman as a member of the Boys' Band.

Wallace Kirkland was completing a degree in social work administration at George Williams YMCA College on Chicago's South Side when he, his wife, Ethel, and their young son, Bud, moved into an apartment on the top floor of the Hull-House Boys' Club Building on Polk Street. After his graduation in 1923, Jane Addams offered Kirkland a position as director of the Hull-House boys' and men's clubs and his wife a job as a social worker. Kirkland had held a series of colorful and diverse jobs before moving to the settlement. The son of British subjects, he was born on a coconut and banana plantation in Jamaica, British West Indies, in 1891 and emigrated to New Jersey with his mother and sister after a hurricane wiped out the family's livelihood. At the age of fourteen, he took his first job in a hard rubber factory; he would also work in a small-town grocery, at the DuPont company's Pompton Lakes plant, where he was in charge of explosive powders (it "gave me religion," he would later reflect), and with a boys' club in Passaic. The latter job led him to YMCA work and a position in Texas as an outpost secretary, traveling the Mexican border during the Pancho Villa uprising in World War I. In 1918, Kirkland married Ethel Freeland and the two moved to Chicago, where he entered George Williams. To help pay expenses while a student, he night-clerked in a State Street flophouse and worked one summer as a troubleshooter for the Yellow Cab Company.

The Hull-House Boys' Club Building was a well-equipped facility that offered almost every imaginable activity to boys and men of the surrounding area. As director of this facility, Kirkland was in charge of one group of boys and oversaw the many other clubs, all directed by

volunteer leaders, that met there. The philosophy of Hull-House at the time was to work as much as possible with natural groups from the neighborhood, using the street gangs organized by the boys themselves as a basis for the settlement's various clubs.

A short time after Kirkland took up his post, the manager of the Eastman Kodak store in Chicago gave the Hull-House Boys' Club a 5 × 7 view camera. "We rigged up a closet in the club for a darkroom, and with the help of the boys I made photographs of the teams, the classes and other activities," Kirkland remembered in *Reflections of a Life Photographer*, written in 1954. "On weekends in the spring I lugged the big camera, the tripod and the plateholders out to the Indiana dunes country and began making close-ups of wild flowers. This was my first photographic hobby." Exactly when he began making photographs at Hull-House is not clear, but the Hull-House yearbook mentions a well-equipped darkroom and photographic studio in the Boys' Club in 1925.

Kirkland continued to live at Hull-House until 1936, but his real interest slowly shifted "from thing sociologic to those photographic." He found himself "spending more time with the problems of the camera in the darkroom, and less with those of the boys in the clubroom . . . thinking more of composition and development than of delinquency and regeneration." For eleven years, Kirkland used the 5 × 7 view camera to make over a thousand photographs of nearly every aspect of Hull-House life. A familiar figure in and around the settlement, he was able to record an insider's view of Hull-House activities during the late 1920s and early 1930s. His comfort with his subjects is evident in the images he created. There is about these photographs an immediacy and a personal quality—an enjoyment, almost, of the very process of being photographed—that pulls the viewer into the frame.

In 1934, Kirkland resigned his position at Hull-House, although he and his family lived there for another two years, and began free-lancing as a writer, lecturer, and photographer. One of his first assignments, taking pictures for a boys' school promotion booklet, established him as an innovator: the opening shot was taken over the shoulder of a boy dissecting an

earthworm. Using this new technique of concentrating on the focus of activity to tell a story, he was soon in great demand, landing several jobs capturing school life throughout the Midwest on film. In 1937, a new magazine called *Life* published a special issue on education, to which Kirkland contributed some of his photographs. His method of interpretation nicely fitted the magazine's concept of photojournalism, and for the next few years Kirkland did several picture stories for *Life*, primarily in the school, farm, and industrial fields.

Life editors gave Kirkland a special assignment in 1940 that he later said he felt he had been preparing for all of his life. He was sent to India, where he spent six months photographing the country and its leaders, notably, Gandhi, Jinnah, Bose, and Nehru. Kirkland recalled that when he first approached Gandhi in his ashram in Wardha, the great man was hostile, saying, "I'll have nothing to do with that capitalistic magazine." But Kirkland persisted, pointing out, "I worked with Jane Addams at Hull-House for several years and I have many things to tell you about her." Immediately, a change came over Gandhi and he invited Kirkland into his tent, allowing him to stay for almost a week to document his daily life.

During the course of that trip, Kirkland sent *Life* over three thousand negatives, more than had ever been taken on a single job by a *Life* photographer. As a result, in 1942 he was made a permanent member of *Life*'s photographic staff, a position he held until his retirement in 1959. In recalling those early years and the many international assignments that followed, Kirkland said, "Being a *Life* photographer is not a profession with me, it's a way of living. Someone once said that happiness is being busy at the thing you like to do. I like photography. I am busy at it and to add to my happiness I get paid for it."

During his retirement years, Wallace Kirkland kept busy with the things he liked best: photography, lecturing, and writing. Already the author of three books—*Recollections of a Life Photographer*; *Lure of the Pond*, a nature study in text and pictures; and a children's book,

Shenshoo, the Story of a Moose—he began work on his final book, *Jamaica Boy*, the story of his childhood. He also began writing down some of his Hull-House memories. I visited Kirkland in his home in Oak Park, Illinois, in the late 1970s, while working on an exhibit about the history of the Hull-House neighborhood. We struck up a friendship, and during subsequent visits he shared with me some of the material he was working on and talked about his Hull-House photographs. A project began to emerge as Kirkland expressed interest in having these photographs exhibited and a book of them published. I began work on this project and in 1979 organized and mounted the first exhibition of prints made from the original 5 × 7 glass plate and nitrate negatives. Shortly thereafter, Kirkland passed away in an Oak Park convalescent home at the age of eighty-eight. When plans started forming for the celebration of the 1989 Hull-House Centennial, it seemed the perfect occasion to bring the project to completion with a book of selected Wallace Kirkland Hull-House photographs.

The sixty-two images in this book were selected from the many available on the basis of several criteria, the first being the detailed information each conveys about the Hull-House programs, activities, and neighborhood during a particular period of time. Arranged as they are, they form a kind of visual tour around the outside of the Hull-House buildings, through the neighborhood, and finally inside, where we are given a close-up look at the settlement's many classes and clubs, its art, theater, and music programs, the gymnasium and library, exhibits in the Labor Museum, its nursery school programs and summer camp, and the staff at dinner and their residential quarters. These photographs were also chosen because of their technical excellence, their composition, their broad tonal range, and their incredible detail.

On another, and perhaps most important level, these photographs were selected because of what they communicate about the *spirit* of Hull-House. In a wonderful article titled "The Play Instinct and the Arts," written in 1930, Jane Addams says: "The patriotism of the modern state must be based not upon a consciousness of homogeneity, but upon a respect for variation, not upon inherited memory, but upon refined imagination. . . . It is always easy for

a democracy which insists upon writing its own programs to shut out imagination, to distrust sentiment and to make short work of recreation. It takes something like a united faith and a collective energy to insist that these great human gifts shall be given the sort of expression which will develop into the arts." It is just this sort of united faith and collective energy, this appreciation of diversity and wonderful respect for imagination, self-expression, and the creation of beauty, that comes through so strongly in this collection of photographs by Wallace Kirkland. And it is what makes them so special.

Acknowledgments

Any project that has been as long in the making as this one owes much to many people. I would especially like to express my appreciation to the following: Wallace Kirkland, Jr., and Judith Kirkland Lamb, for providing information about their father; Bob Natkin, for his early support of this project; Richard Mather, for making excellent prints from the original negatives; Mary Lynn McCree, for introducing me to Wallace Kirkland in the first place; Larry Zimmerman, for constant encouragement; Joan Gittens, for saying something that suggested the title; Theresa Sears, for excellent editorial help; and Mary Jane Beech, for pulling me through.

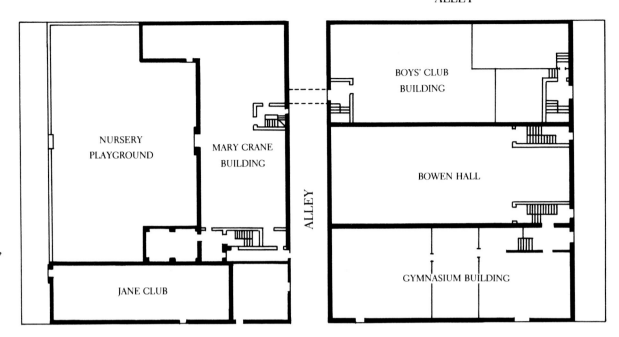

ALLEY

POLK STREET

BOYS' CLUB BUILDING

NURSERY PLAYGROUND

MARY CRANE BUILDING

BOWEN HALL

ALLEY

JANE CLUB

GYMNASIUM BUILDING

A plan of Hull-House buildings, from the program announcing the Spring Exhibit and Fortieth Anniversary Celebration of Hull-House, May 9–11, 1930.

ALLEY

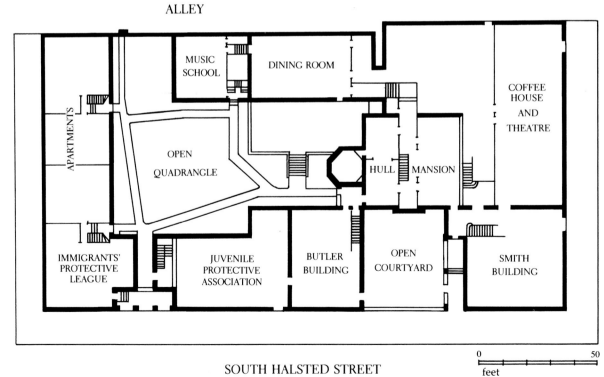

GILPIN PLACE

MUSIC SCHOOL

DINING ROOM

COFFEE HOUSE AND THEATRE

APARTMENTS

OPEN QUADRANGLE

HULL MANSION

IMMIGRANTS' PROTECTIVE LEAGUE

JUVENILE PROTECTIVE ASSOCIATION

BUTLER BUILDING

OPEN COURTYARD

SMITH BUILDING

SOUTH HALSTED STREET

0 50
feet

THE MANY FACES OF HULL-HOUSE

1

The Hull-House buildings at the corner of Polk and Halsted streets in the late 1920s. By this time, the thirteen-building complex covered nearly a city block, extending from Polk Street on the north to Gilpin Place on the south, and from Halsted Street on the east to an alley on the west. The building on the corner, which became the visual landmark of Hull-House, is the Smith Building (1895). To the left is the original Hull Mansion (not visible in this photograph), which is set back from the street; the Butler Building (1891); the Men's Club Building, which housed the Juvenile Protective Association on the first floor; and the Hull-House Apartment Building (1902).

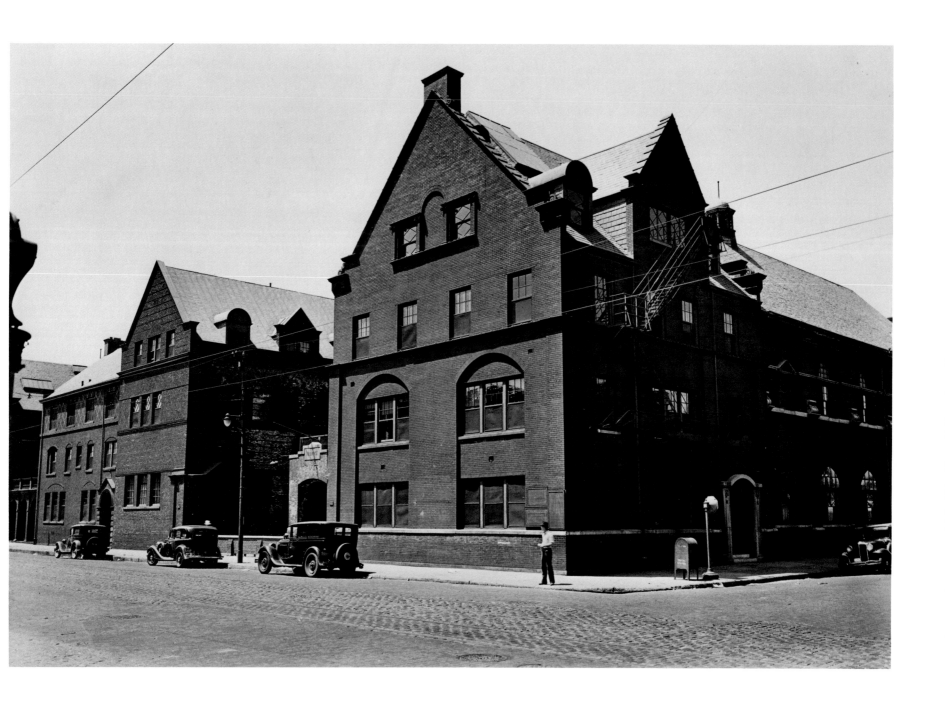

2

Looking north on Halsted Street in the mid-1920s, the
Hull-House complex on the left. At the time, Halsted
was a main thoroughfare, cutting Chicago in half from
north to south; streetcar route no. 8 ran past Hull-House.
The Geis Clothing Company, located across the street at
829 South Halsted, operated from 1921 to 1927. The
most prominent building in this photograph is the Hull-
House Apartment Building, on the southwest corner of
Halsted and Gilpin Place.

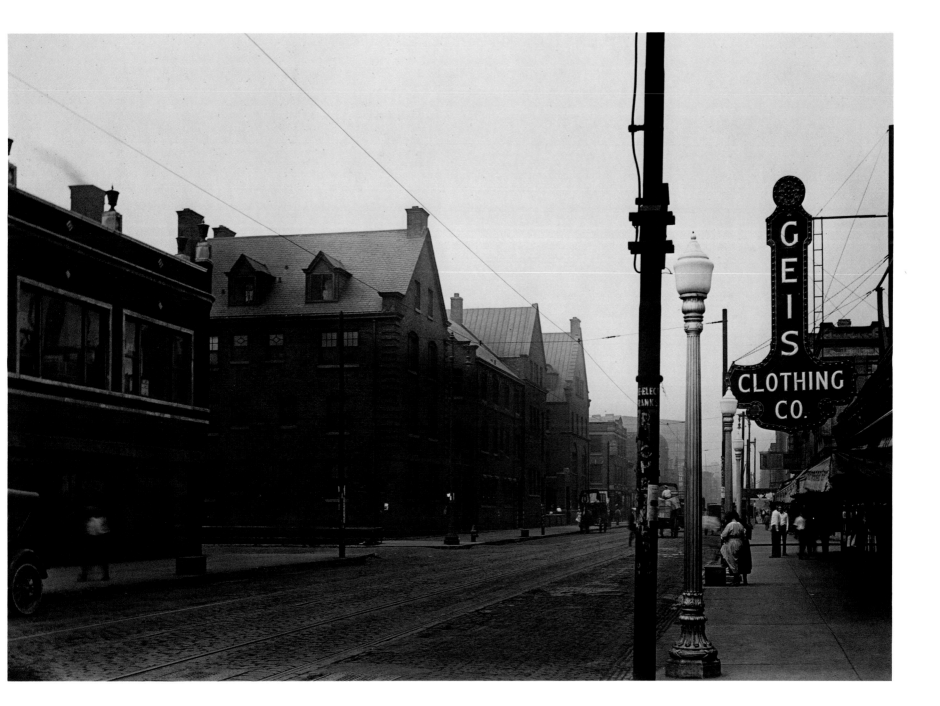

3

Looking west on Polk Street from Halsted, late 1920s. The Polk Street frontage, from left to right: the Smith Building; the Coffee House and Theatre (1899); the Labor Museum and Gymnasium, which had been moved, remodeled, and expanded in 1900; Bowen Hall, the Women's Club Building (1904); and the Boys' Club Building (1906).

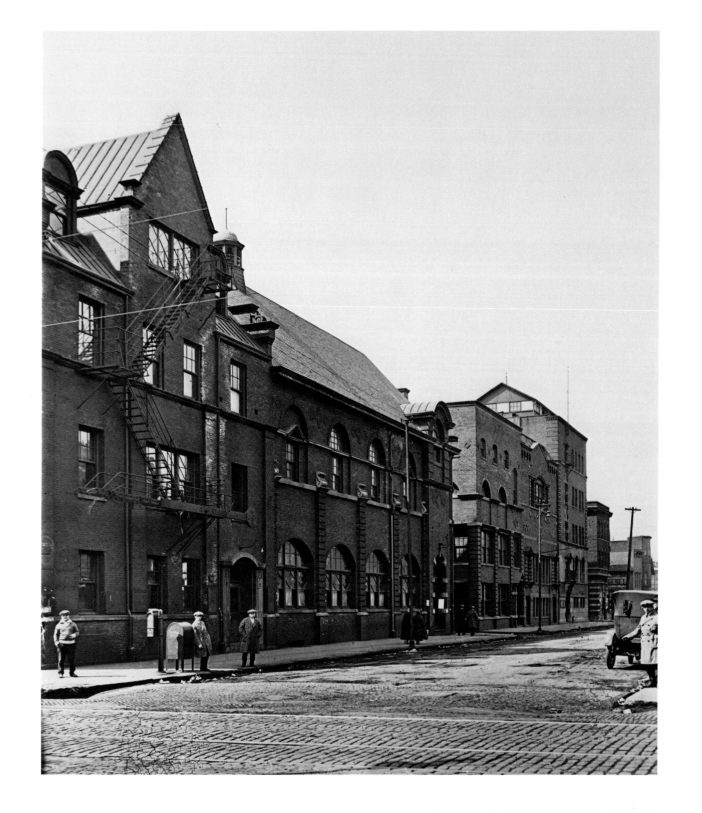

4

A Greek pastry shop located at 607 South Halsted Street, two blocks north of the Hull-House complex. The Greek community, which stretched north of Hull-House along Halsted in the 1920s, was the largest in the United States at the time. Greek stores and businesses lined Halsted, Blue Island, and Harrison, forming a triangular piece of land, commonly called the Delta, which marked the nucleus of the community.

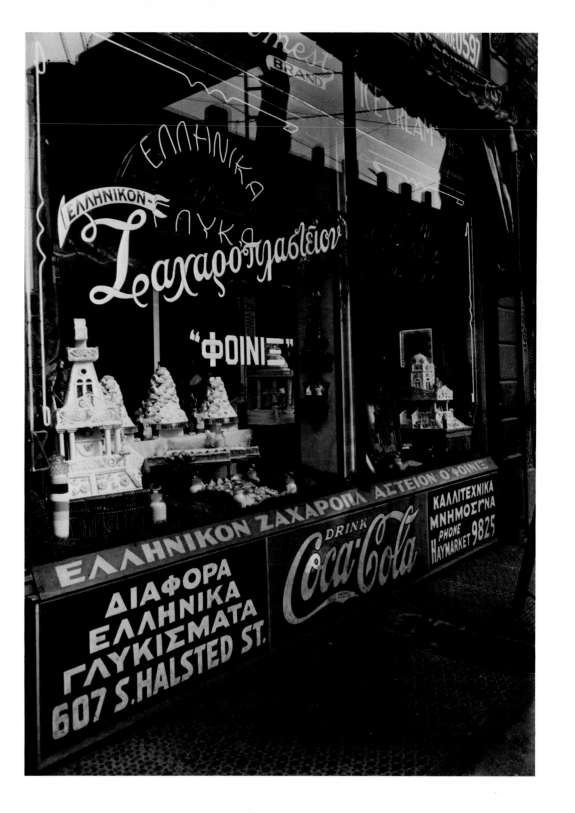

5

Greek men from the neighborhood cooking lambs on
Holy Saturday over an open fire behind a store on
Halsted Street, in preparation for a Greek Easter feast the
following day. By the 1920s, the Greek community was
heavily involved in the activities of Hull-House, the
Greek Olympic Athletic club having met there for several
years. Other Greek groups turned to the settlement on a
regular basis for education programs and general
information on a variety of subjects.

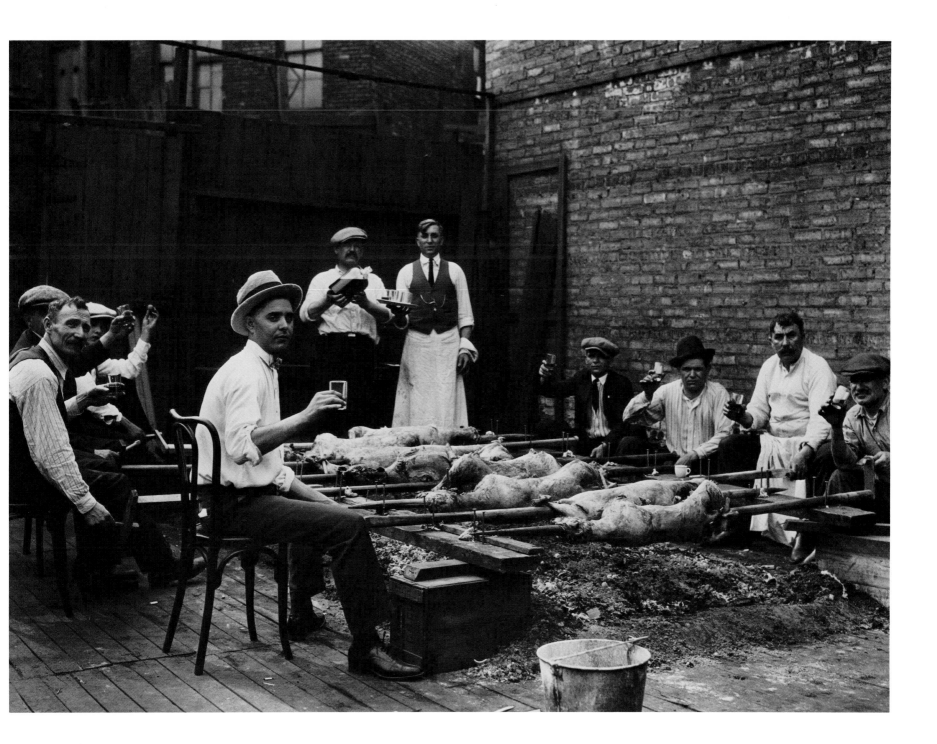

6

A young shoeshine boy from the neighborhood peers into the window of a Greek bread shop on Halsted Street. Large circular loaves of bread called *Christopsomo* (Christ bread), baked with the shape of the cross and containing eggs, the symbol of resurrection, are on display in preparation for Greek Easter.

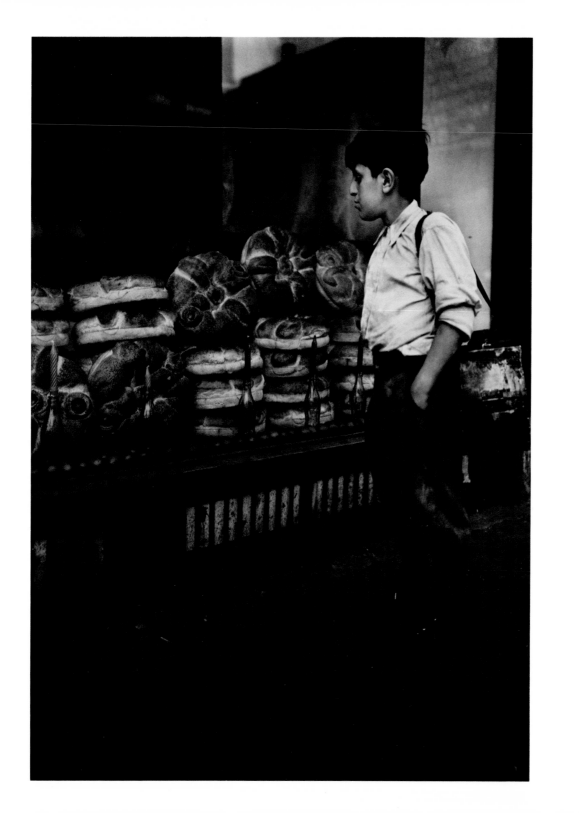

7

While the area north of Hull-House was primarily Greek, the community east of Halsted Street was, in the 1920s, still heavily Italian. This group of Italian boys, most of whom lived in the 700 block of Forquer Street (later renamed Arthington Street), had just finished building a clubhouse from materials found in a nearby alley when they were caught by Wallace Kirkland's camera in 1924. Kirkland later organized them into a Hull-House club called the Silver Rivers.

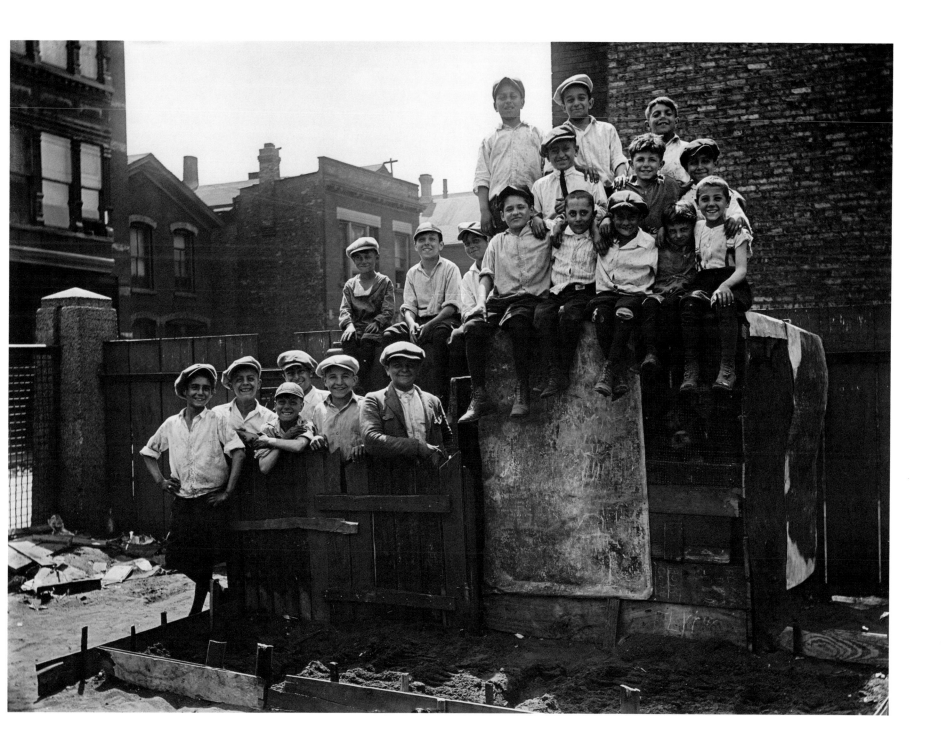

8

Members of the West Side Sportsmen's Athletic
Association. Organized in 1920, this Hull-House club
was made up mainly of Italian men from the immediate
neighborhood who met regularly for social, athletic, and
educational activities. Here, members prepare to build a
fence around a baseball field in an empty lot just west
of Hull-House.

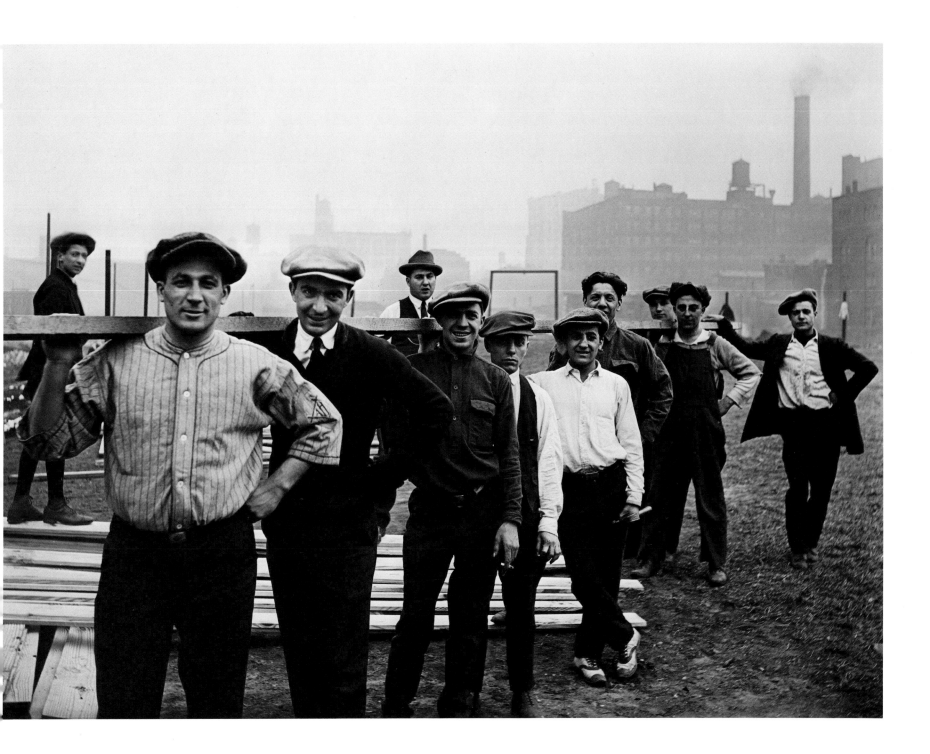

9

A demonstration of traditional needlework in the Hull-House Labor Museum, created by Jane Addams in 1900 to preserve the arts and crafts of ethnic groups in the surrounding neighborhood and to forge a link between the traditions of first-generation immigrants and the experiences of their children.

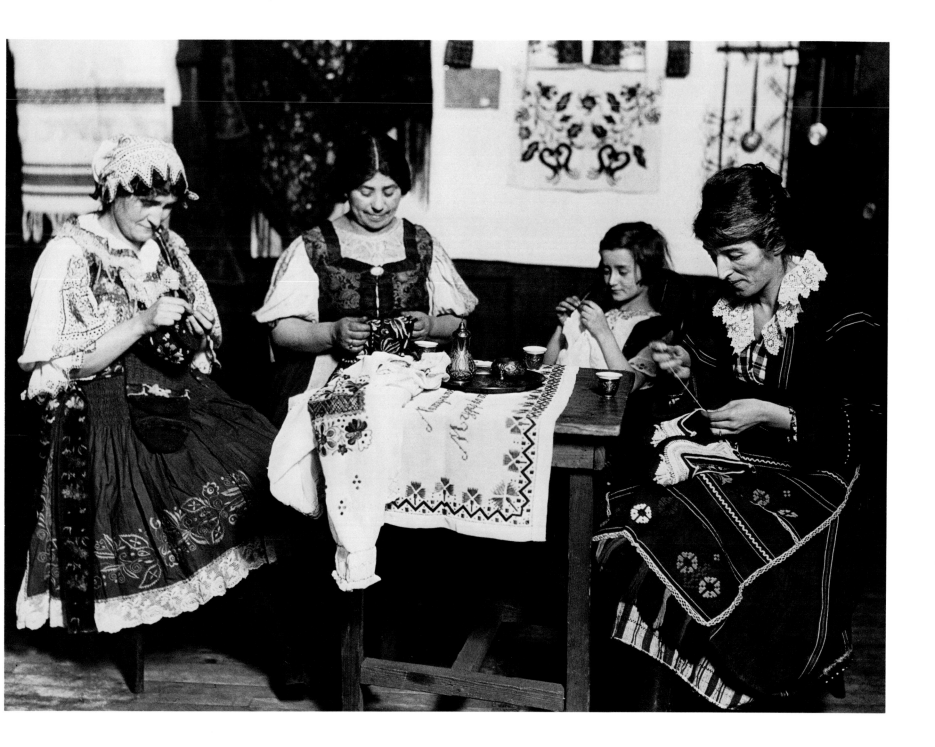

10

By the late 1920s, the Labor Museum, with its emphasis
on learning by doing, was a popular means of introducing
people from the neighborhood to the activities of
Hull-House. Here, a woman from the community
demonstrates a traditional method of spinning
with a wheel; in the background are textiles made on
a Labor Museum loom.

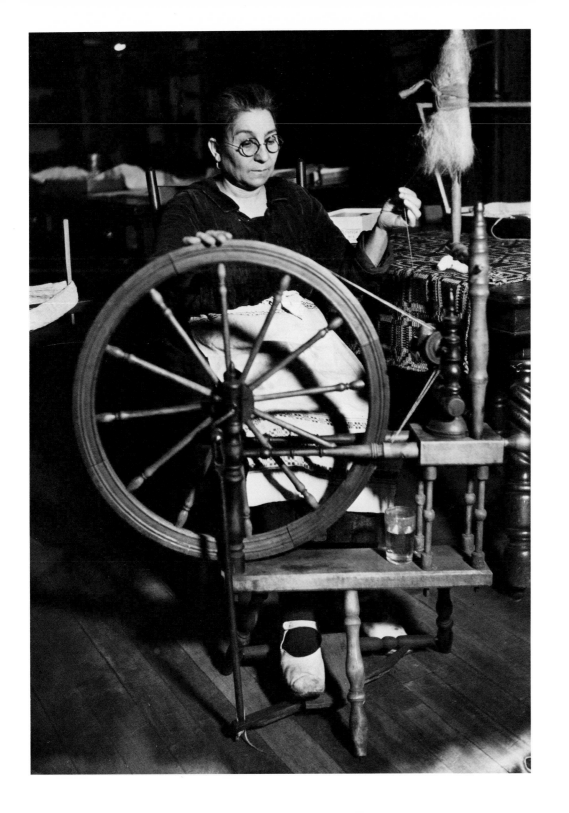

11

A man working at a four-harness loom in the Hull-House Labor Museum. Jane Addams believed that "the best education cannot do more than constantly reconstruct daily experience and give it a relation to the past as well as an understanding of contemporary life."

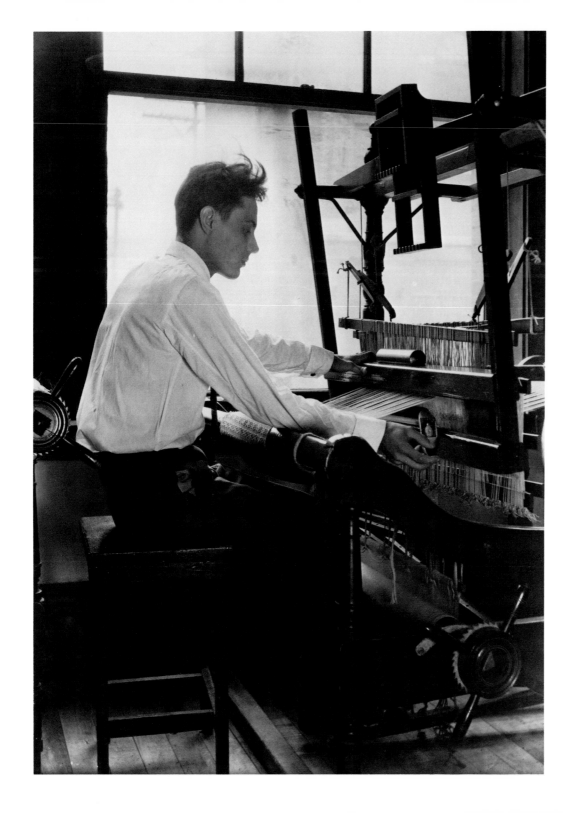

12

A neighborhood woman demonstrates the hand-held method of spinning in the Hull-House Labor Museum. Note the distaff pinned to the woman's dress and tucked under her left arm.

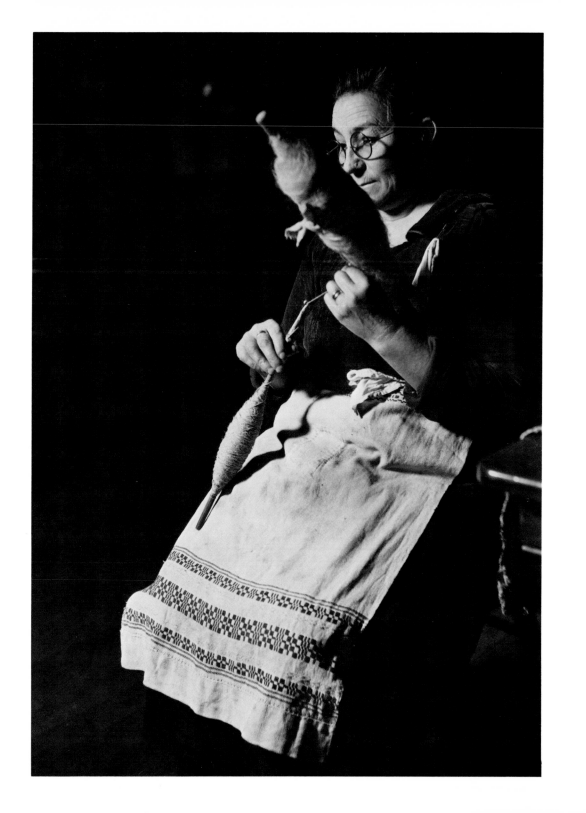

13

During the 1920s, the shops and textile area of the Hull-House Labor Museum were used for many classes and demonstrations. In this photograph, a Mexican men's club uses the space for a pottery class. In the background are cooking class utensils and artifacts borrowed from the Field Museum of Natural History, arranged to illustrate the historic background of the skills taught and demonstrated in this room.

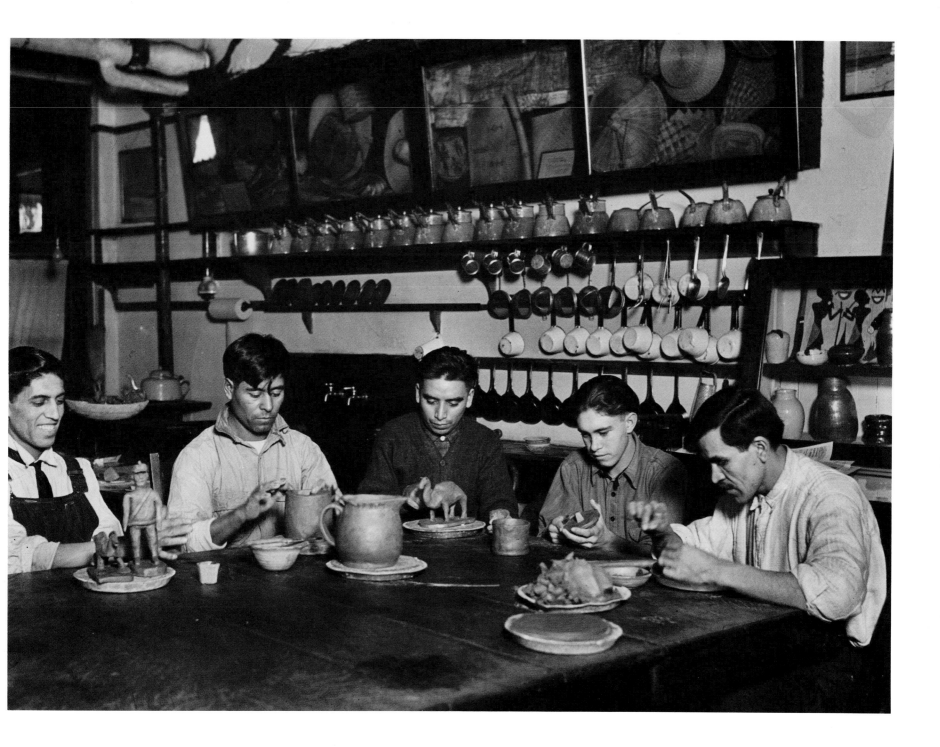

14

By the late 1920s, Mexicans had become one of the largest ethnic groups in the Hull-House neighborhood. Chiefly natives of the states of Michoacán, Jalisco, and Guanajuato, many of them were skilled artisans who became extensively involved in the pottery work at Hull-House. Here, Jesus Torres, a neighborhood resident who originally came to Hull-House as a student, demonstrates his craft.

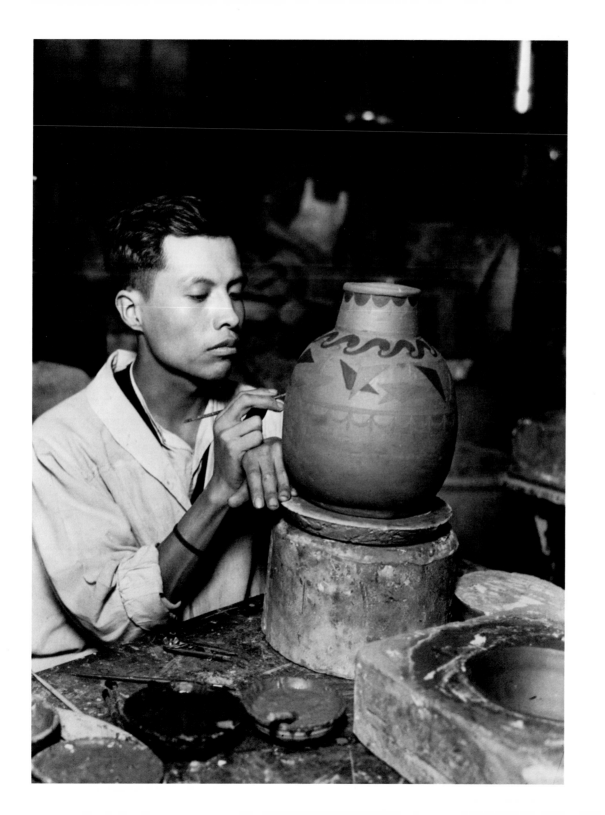

15

In 1927, the Hull-House Kilns was organized by settlement residents Beals and Myrtle French. Mexican artisans from the neighborhood played a significant role in this venture and were noted for their generosity in teaching their technique to young students. By 1930, Hull-House had become a meeting place for several local Mexican organizations.

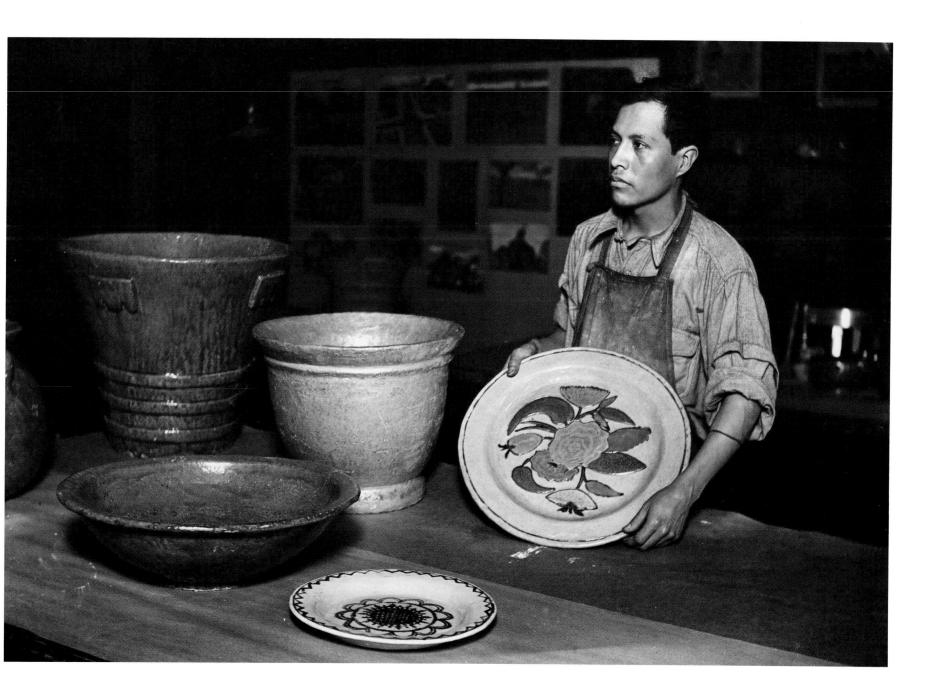

16

Nick Fosco, a neighborhood Italian, became foreman of the Hull-House Kilns. The small pottery factory made use of talent uncovered in the settlement art classes and produced saleable products. Fosco, an athlete who trained in the Hull-House Gymnasium, previously made his living as a prizefighter, capturing the welterweight title in the 1928 Golden Gloves tournament.

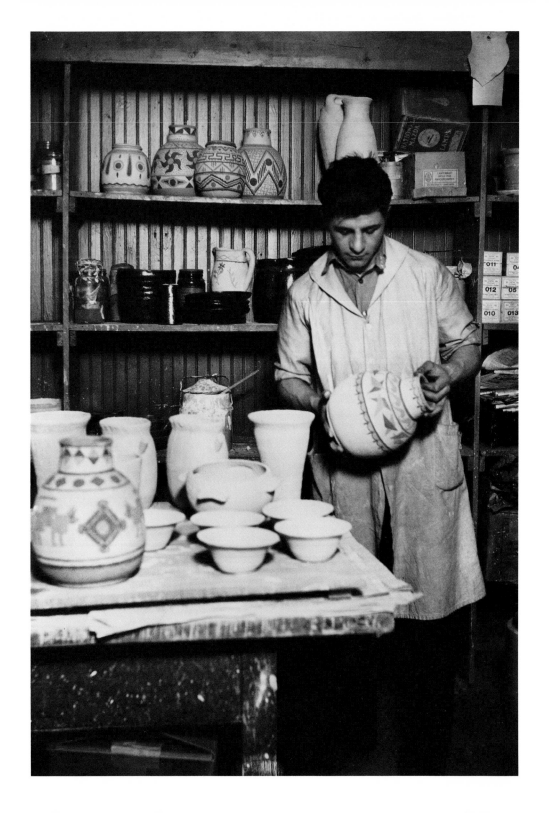

17

By the 1920s, Hull-House was recognized worldwide for its innovative programs and reforms and was a frequent stop for foreign travelers to Chicago. The settlement was visited in 1928-29 by Sarogini Naidu during her lecture tour of the United States and Canada in which she interpreted Hindu womanhood and the ideals of nonviolence. Naidu, a follower of Mahatma Gandhi and a leader in the movement for Indian independence, was also an advocate of female education and woman suffrage.

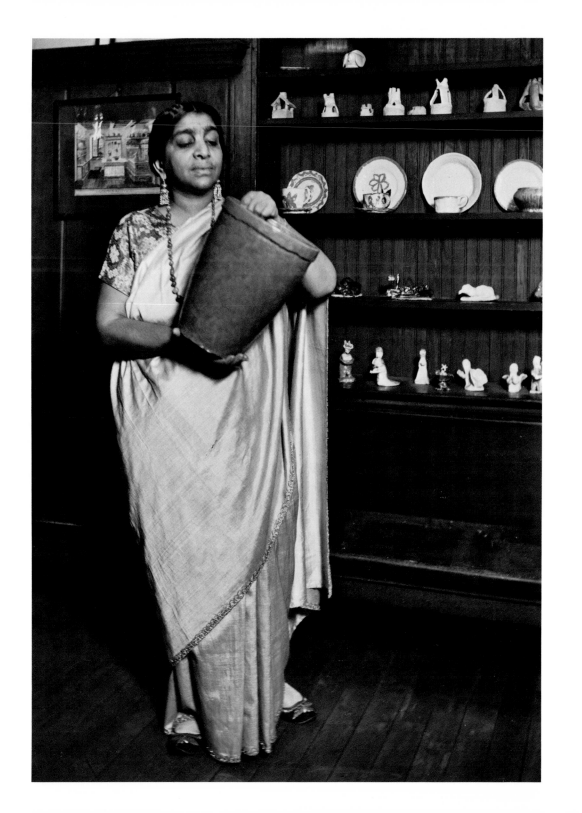

A neighborhood girl in one of the Hull-House children's art classes. A settlement yearbook from 1929 states: "Many different materials are used, clay modeling, work in wood, painting. Working on the supposition that all children are creative and entitled to express themselves . . . they have been allowed to use their imaginations with as little restriction as possible upon the spontaneity of their interpretations."

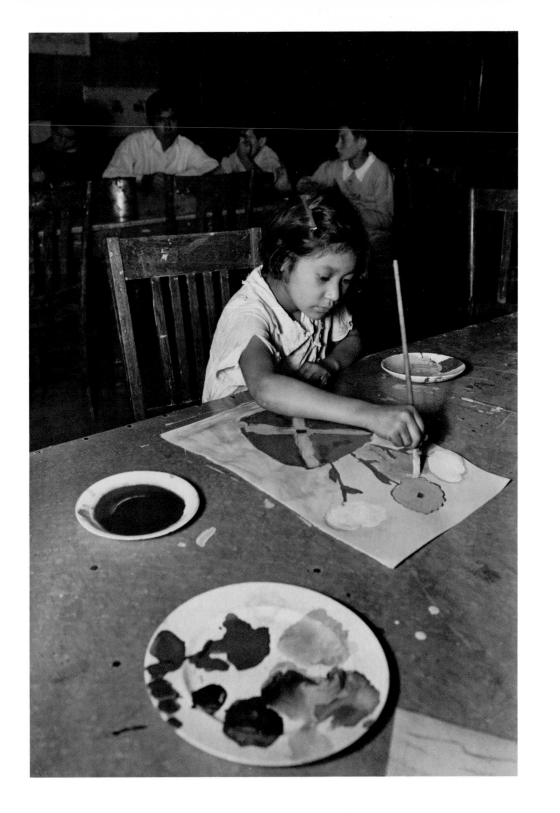

19

A neighborhood boy in one of the children's art classes at Hull-House. A 1931 yearbook entry states: "The staff of Hull-House artists, knowing the children of the neighborhood, their struggles, needs and possibilities, as well as the beauty of their efforts, regard the art school as a movement from which the artists [teachers] themselves have gained as much as the children."

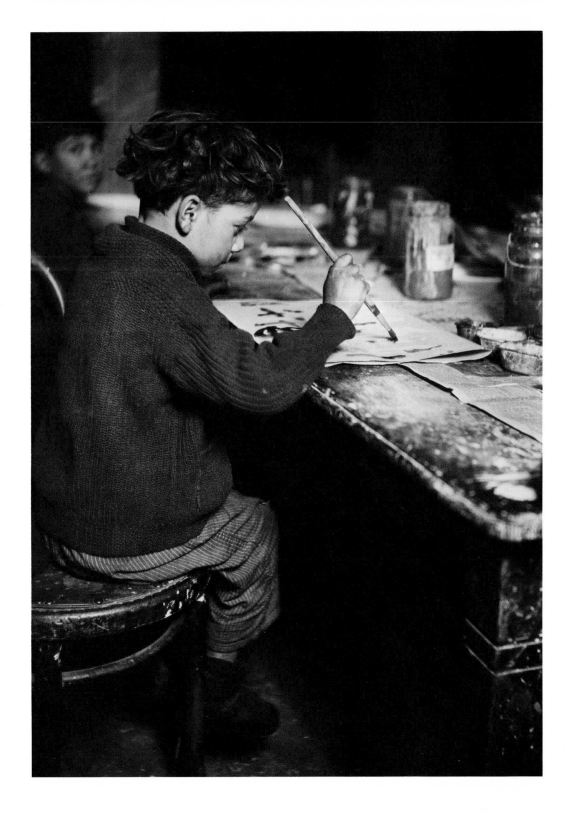

20

Neighborhood gypsy girls in a Hull-House children's art class. During the 1920s, Gypsies could be found living up and down Halsted Street on either side of Hull-House. In a *Survey Graphic* study published in 1927, Hull-House residents reported this to be the largest Gypsy winter colony in the United States.

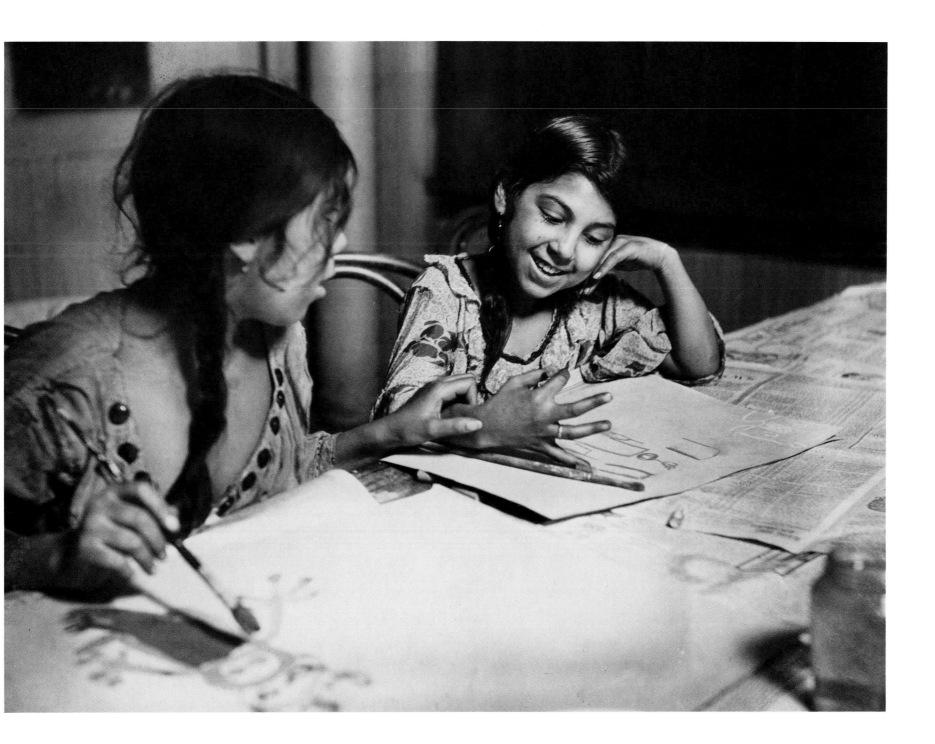

A girls' cooking class offered in the kitchen area of the Hull-House Labor Museum as part of the settlement's domestic science program. In one corner of the room is a colonial fireplace equipped with old brass and copper kettles, which served as a historic background for the modern-day cooking classes. Exhibits borrowed from the Field Museum of Natural History on primitive methods of food preparation are in cases on the wall. The recipe on the blackboard is for fruit cobbler.

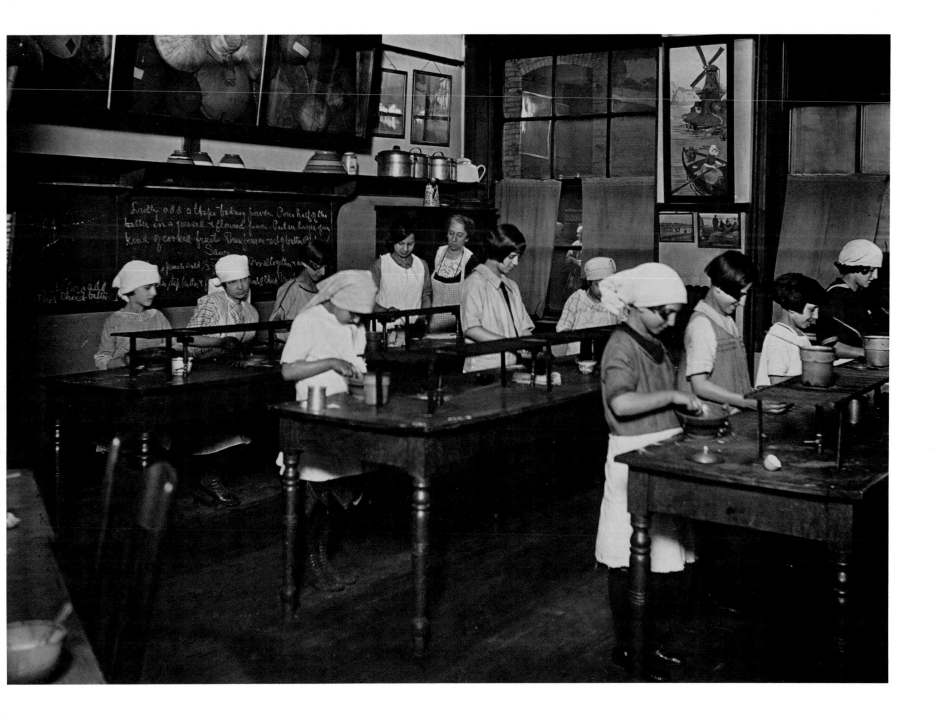

Every day after school, all the available rooms at Hull-House were occupied by clubs and classes made up of neighborhood children. In the mid 1920s, the average weekly attendance was about one thousand, with sixty-four clubs and classes in existence. Pictured here is a children's after-school sewing class, which met in the Smith Building.

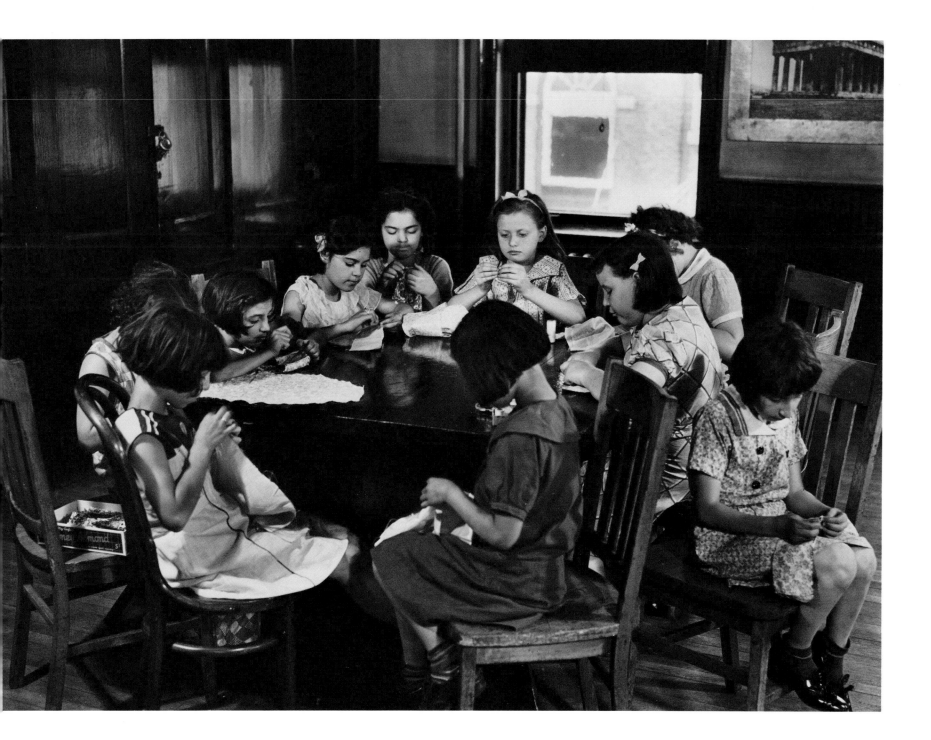

23

A Hull-House doll club, one of the special-interest groups to emerge from associations formed through the more loosely structured Friday Play Club. The 1931 Hull-House yearbook states: "The numerous clubs of young people wishing to meet at the House every week are abundant evidence of the urge for group and social life about us. For the club leader who is alive to the human relationships there revealed, participation in such a group is a stimulating experience which often results in years of association and friendship."

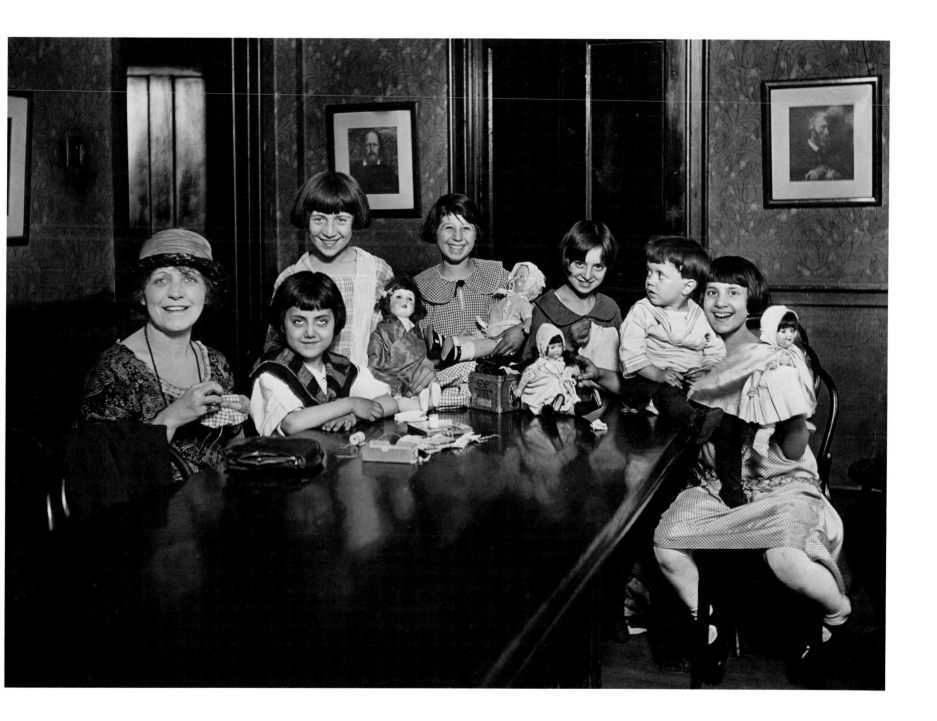

24

Sewing and dressmaking classes for neighborhood women were very popular during the 1920s and 1930s, eventually taking in more than two hundred pupils a year. Here, a class of primarily Mexican and black women from the surrounding area meets in the Smith Building. Note the photograph of the Acropolis on the wall.

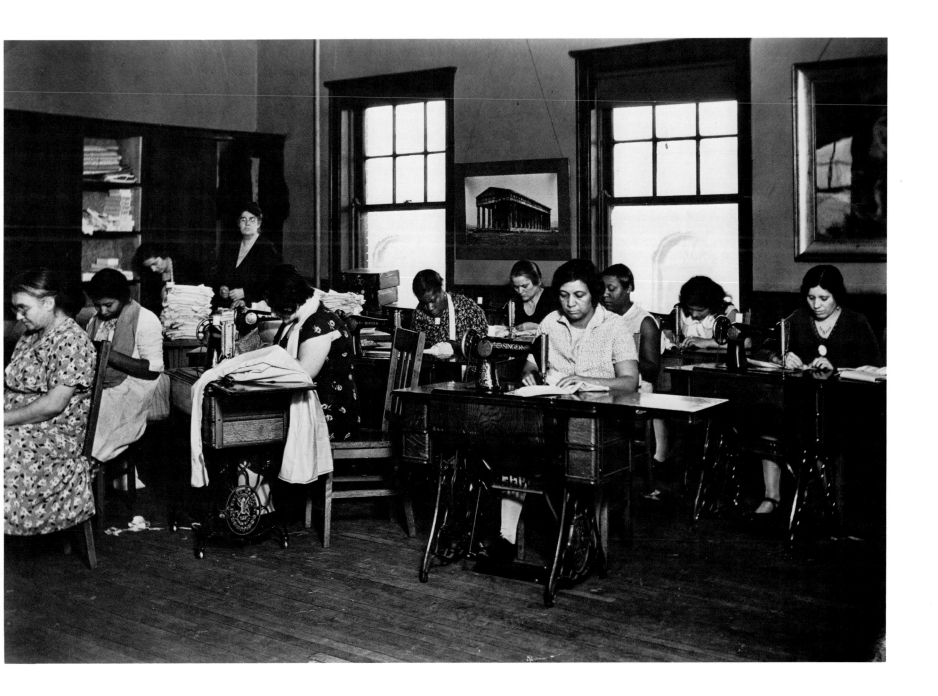

25

Members of the Flash Arrows Boys' Club, one of several small groups at Hull-House directed by volunteer leaders. The 1925 Hull-House yearbook states: "These clubs are formed from the groups known on the streets as gangs. Their gang organization and control, worked out automatically by the boys themselves, are carried over from the street into the clubs."

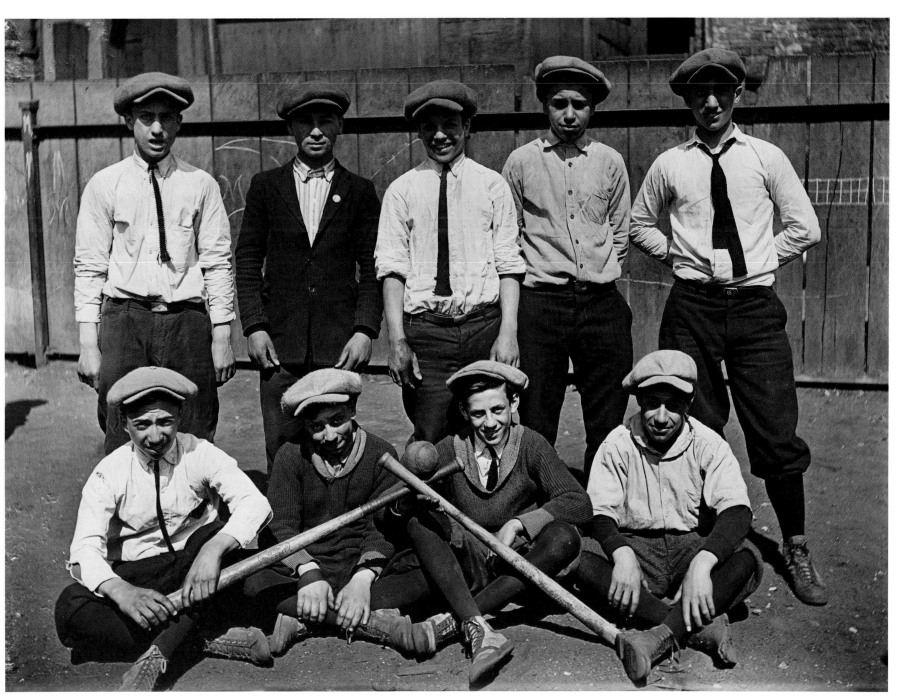

135,726

26

Some of the members of the Comets, a Hull-House club
of neighborhood boys organized by Wallace Kirkland
shortly after he came to the settlement. The club's
activities included basketball, baseball, and gymnastics,
as well as dancing and dramatics.

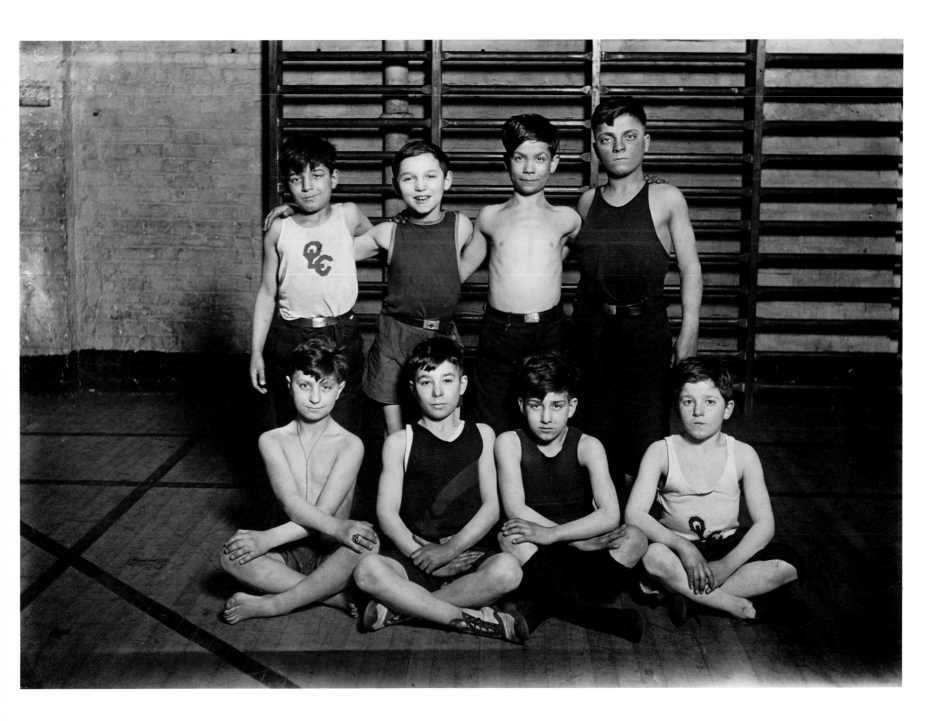

Hull-House established the first public gymnasium in Chicago in 1893 and, a short time later, the first women's basketball team in the city. By the mid-1920s, the Hull-House Gymnasium had been enlarged to include bathing facilities for the neighborhood, and the program was reorganized so that it more nearly conformed to that of the Boys' Club. In 1925, it was reported that over 6,000 paid showers and 12,000 baths were taken in the gymnasium building.

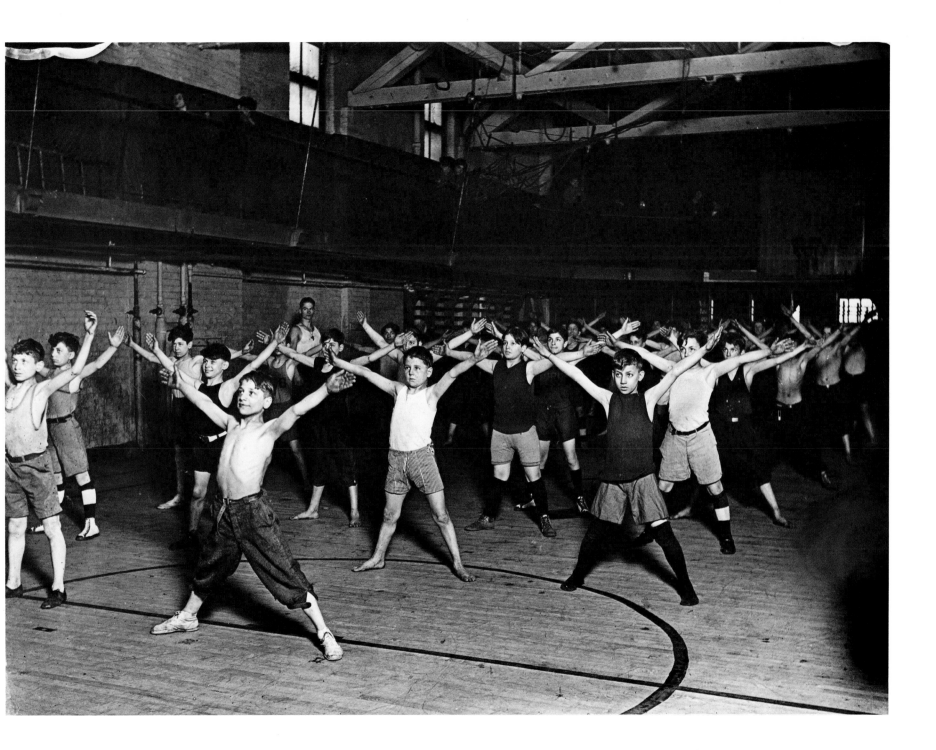

28

A junior boys' gymnastics class in the Hull-House Gymnasium, led by Andrew Kovach. The smallest boy, directly in front of the instructor, is Wallace Kirkland, Jr., son of the photographer.

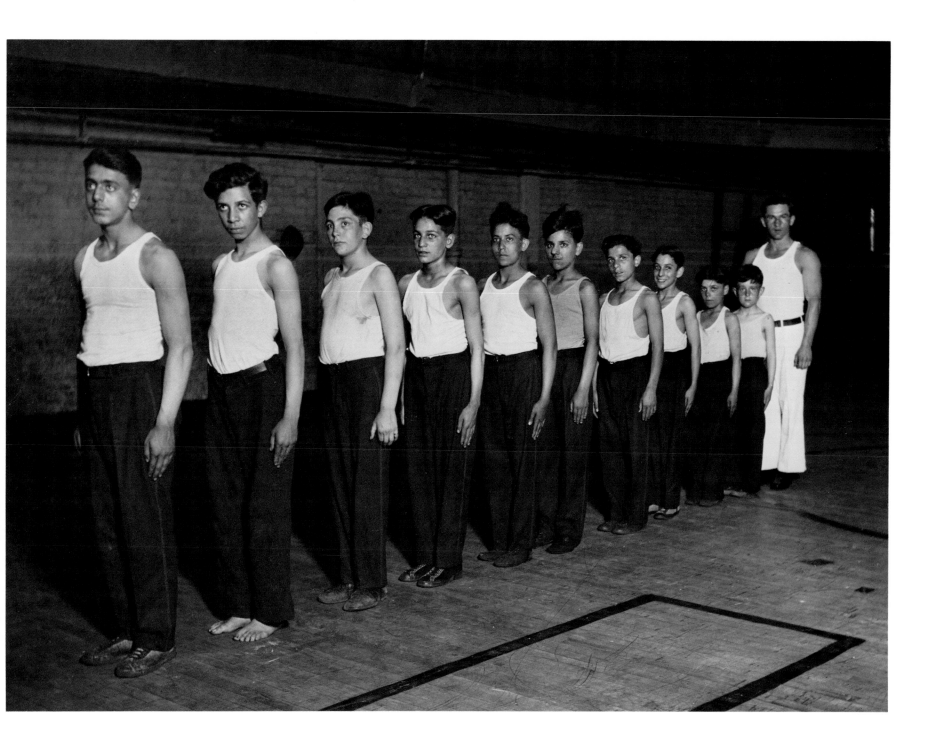

The Manual Training Shop was located on the first floor of the Boys' Club Building. A five-story structure on Polk Street, the building was dedicated in 1907 and devoted to work with boys and young men. It contained, in addition to the workshops, billiard rooms and bowling alleys, a library and study, club rooms, classrooms, social rooms, a band room, and a printing shop.

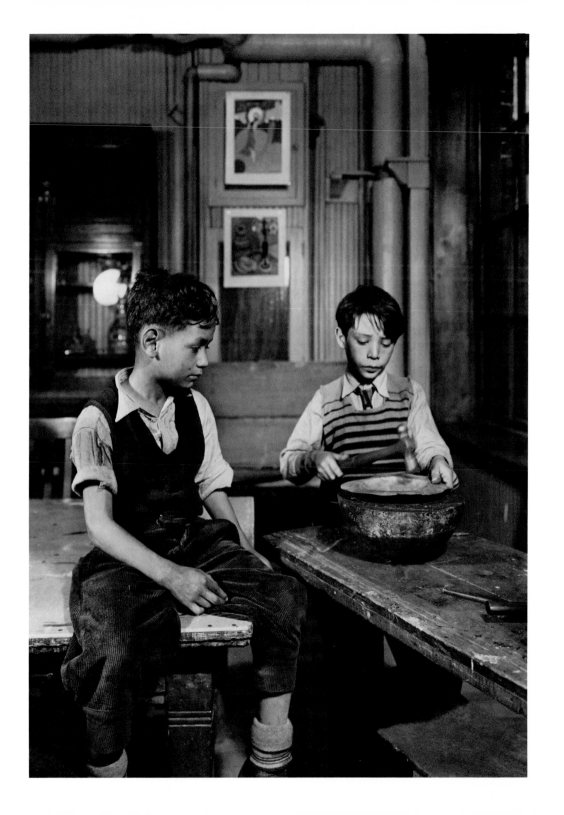

30

Mike Falano, a neighborhood resident and member of the Hull-House Boys' Club, at work in the Manual Training Shop. In addition to a power-driven lathe, the shop was equipped with workbenches, a drill press, a band saw, and a grindstone.

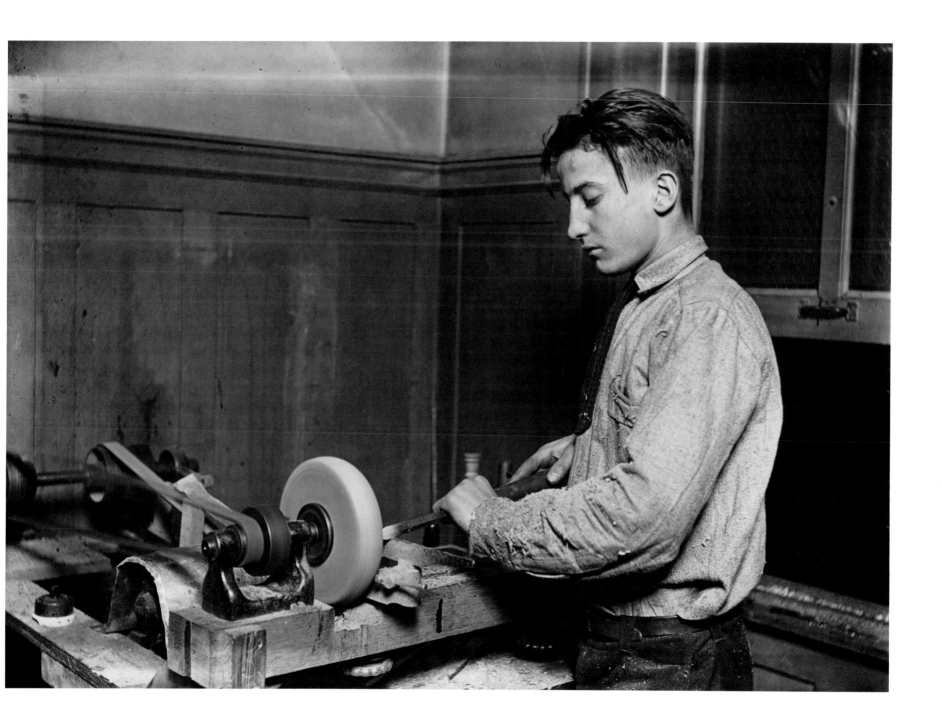

31

Peter Vrouvas, caning a chair seat in the Manual
Training Shop of the Hull-House Boys' Club. The shop
also offered classes in pattern making, mechanical
drawing, stenciling, design, and sign painting.

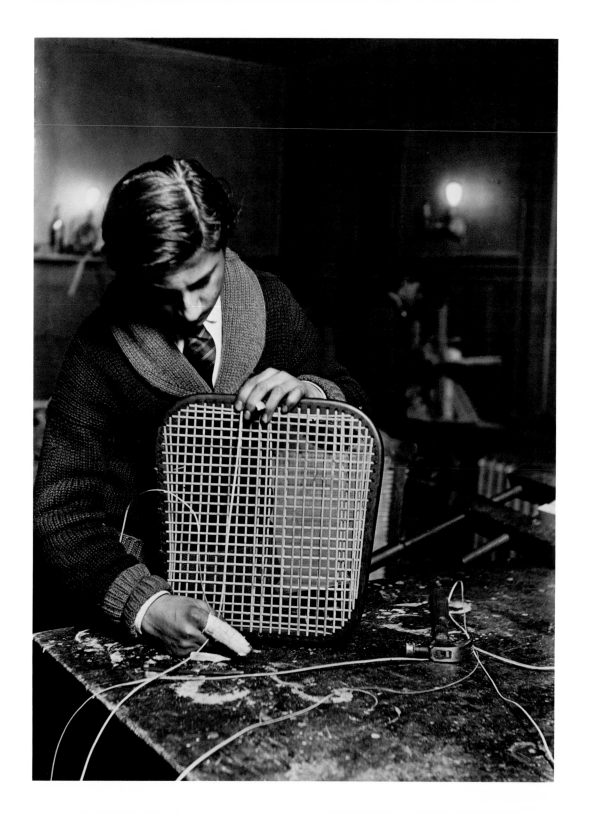

The Hull-House Boys' Band, in uniform, on Polk Street, with the Boys' Club Building on the left. Organized in 1907, the band was one of the most prestigious activities of the Boys' Club. With a playing membership of sixty, it was reported in the mid-1920s that "some of the former members are now playing with the best bands and orchestras of the country, including that of Paul Whiteman and the Chicago Theatre." Benny Goodman, a neighborhood boy, was a member of this band in 1922.

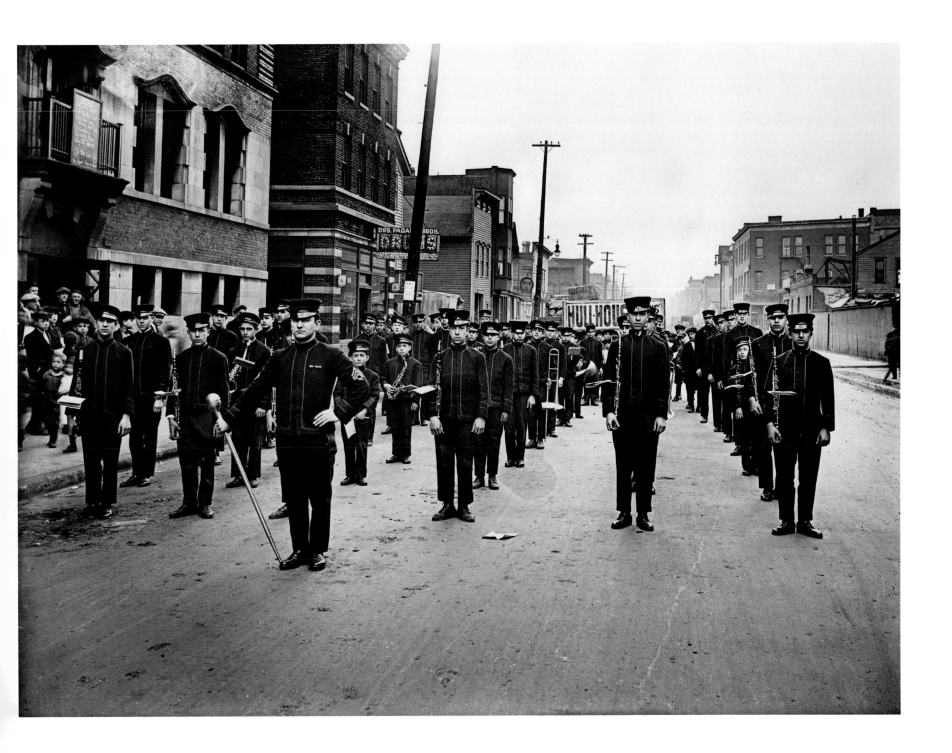

33

James Sylvester, teacher and leader of the Hull-House Boys' Band since its organization in 1907, instructs a member of the band's beginner's class.

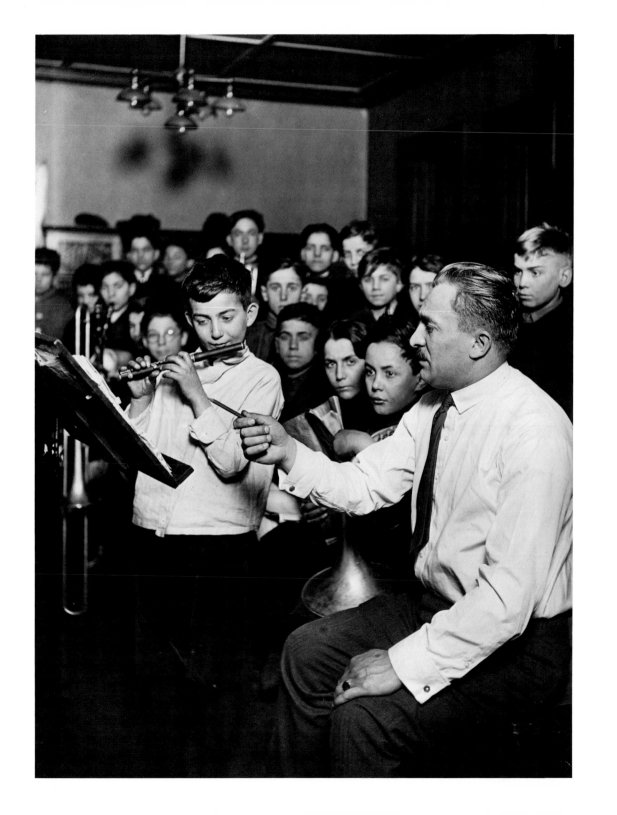

34

Students from the Hull-House Music School, which was
begun in 1893 "to give thorough musical instruction to
those children showing the greatest aptitude and to foster
in a much larger group the cultural aspects of a musical
education." By the 1920s, the Music School offered
instruction in piano, violin, organ, theory, and singing
and was the oldest settlement music school in
the country.

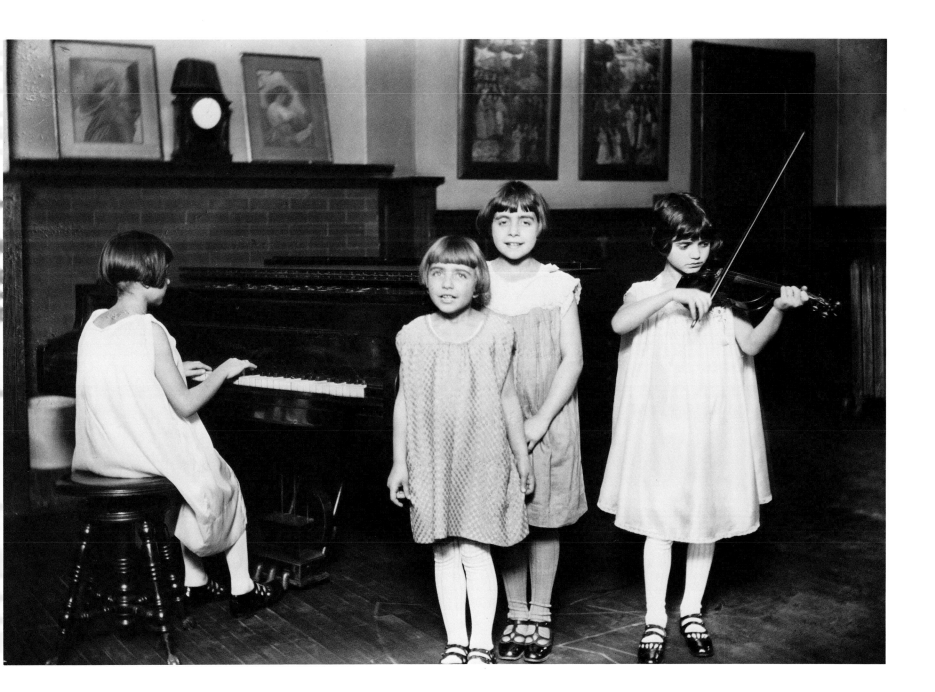

35

Hull-House Music School students prepare for one of their numerous concerts. Many early students of the Hull-House Music School had, by the 1920s, become professional musicians, "and the group as a whole had contributed much to the understanding and appreciation of music in the neighborhood."

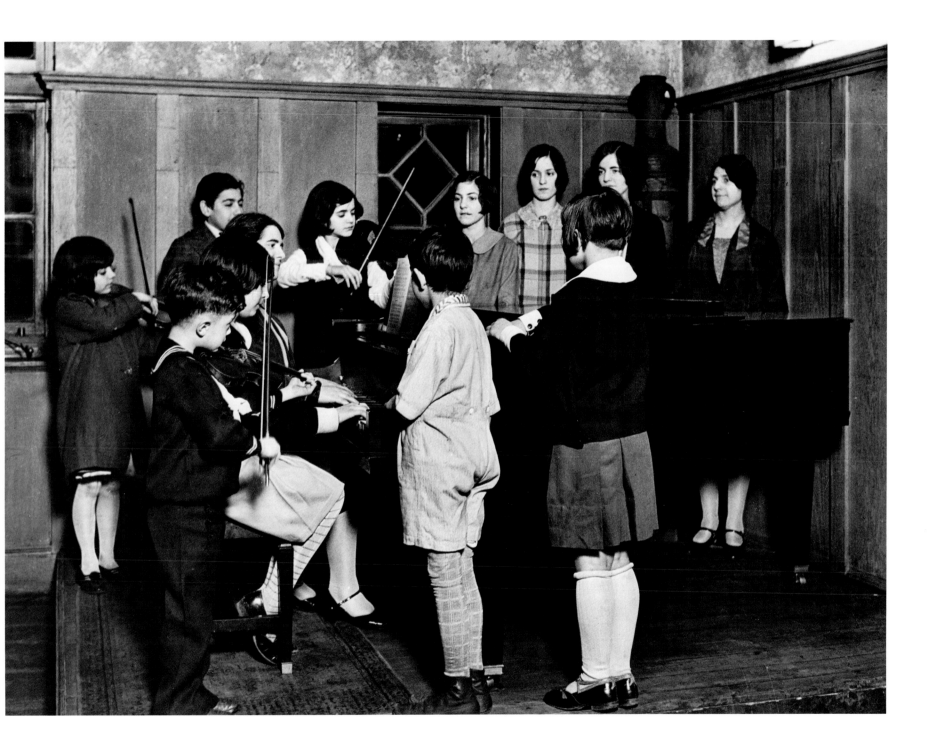

36

Martha Scott worked specifically with gangs of difficult boys in the Hull-House neighborhood, teaching them to sing and exposing them to the soothing qualities of music. Her motto was, "Sing and you'll be good."

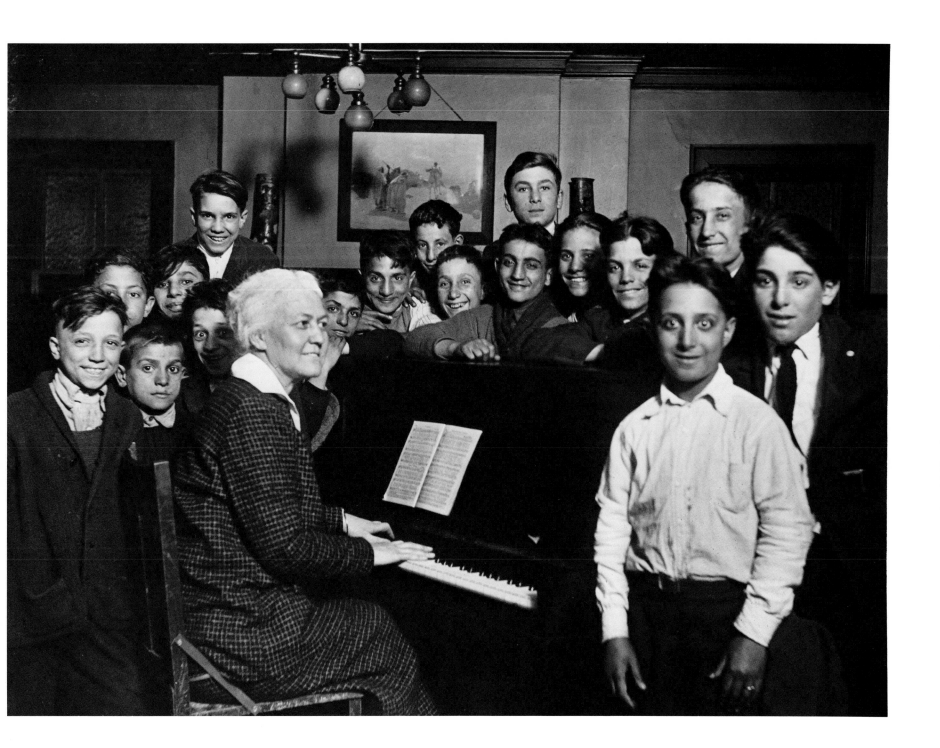

One of the many dramatic productions offered at Hull-House in the late 1920s. The motto above the stage reads: "Act well your part. There all the honor lies." According to the 1925 yearbook: "A method of education which has been gradually used more and more at Hull-House is that of dramatics. . . . the Hull-House Theatre has made a place for itself in the life of Chicago."

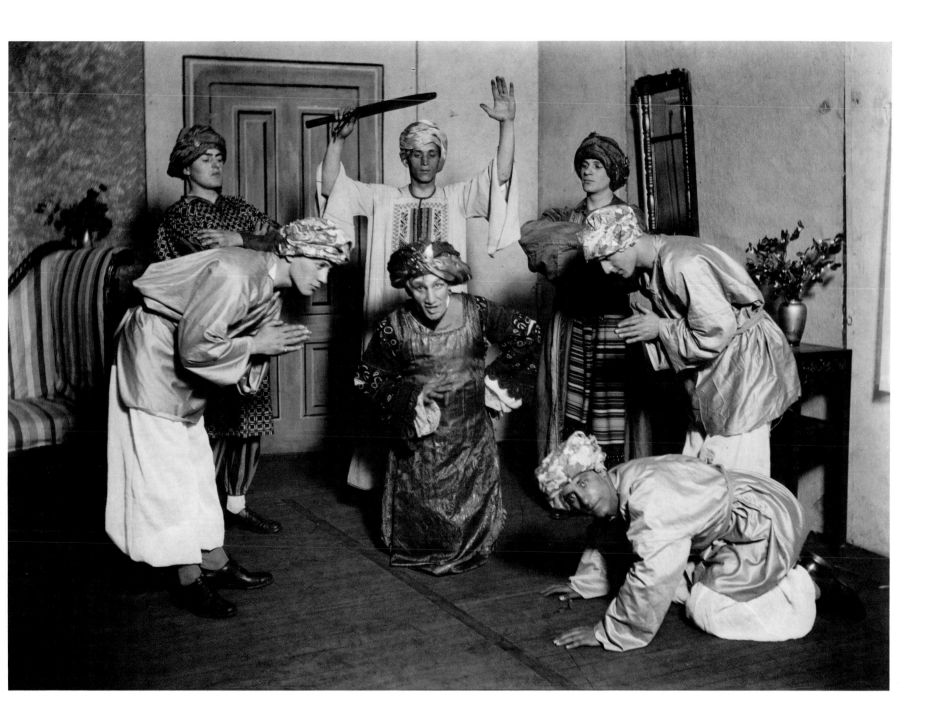

The Marionettes, one of Hull-House's junior dramatics groups, in a mid-1920s performance of *Le Bourgeois Gentilhomme* by Molière. Edith de Nancrede, the group's leader at the time, stated: "Of all the modes of artistic expression, the one with perhaps the most universal appeal is the drama. Certainly we at Hull-House have found no other means so successful in holding a large group together from childhood, through adolescence and into maturity."

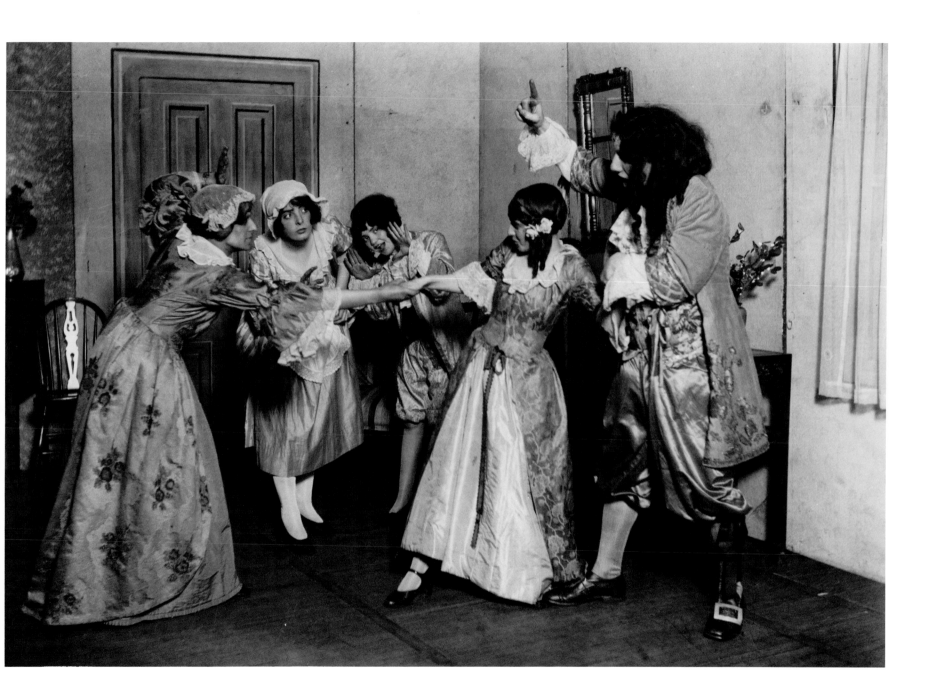

39

The Mignonettes, another of Edith de Nancrede's theater and dance groups, in a mid-1920s performance of Shakespeare's *Twelfth Night*. De Nancrede noted: "After observing for some twenty-five years its remarkable results in the form of charming and interesting young people, I am fully convinced that there is no force so powerful as that of the drama in awakening and stimulating interest in intellectual and beautiful things. And to me it has an even greater quality—the power of freeing people from inhibitions and repressions."

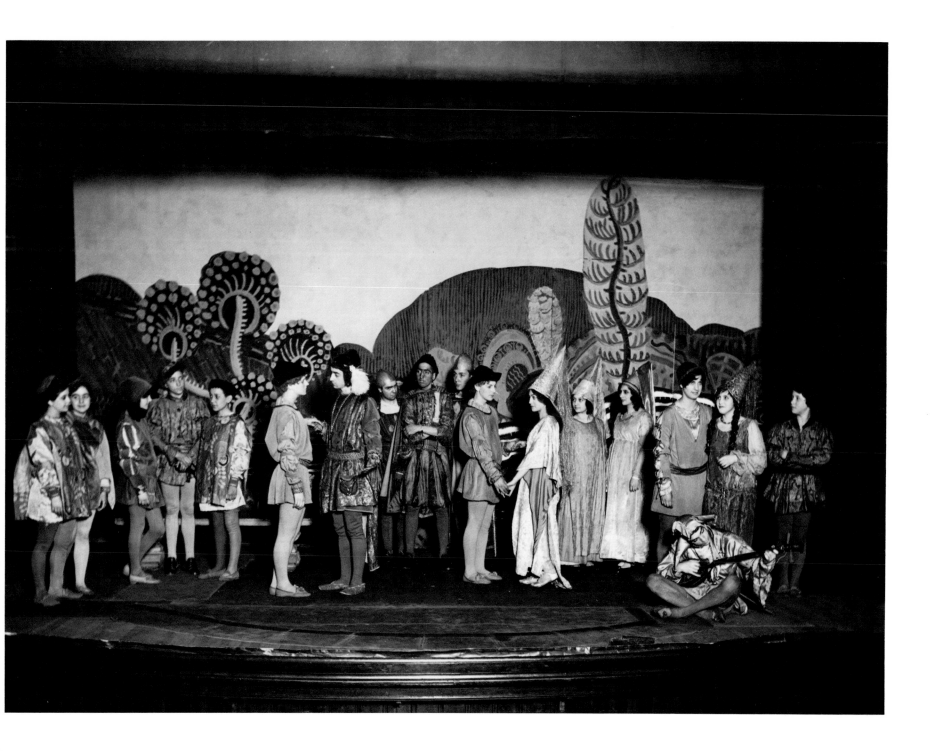

The Christmas Tableaux, an annual tradition at Hull-House from 1911 on, drew on the talents of theater, art, and music students to create an elaborate production of Humperdinck's *Christmas Cantata*. A series of colorful tableaux, costumed and set after Italian pre-Raphaelite paintings, were presented on stage as Music School students, standing below, accompanied each one with song.

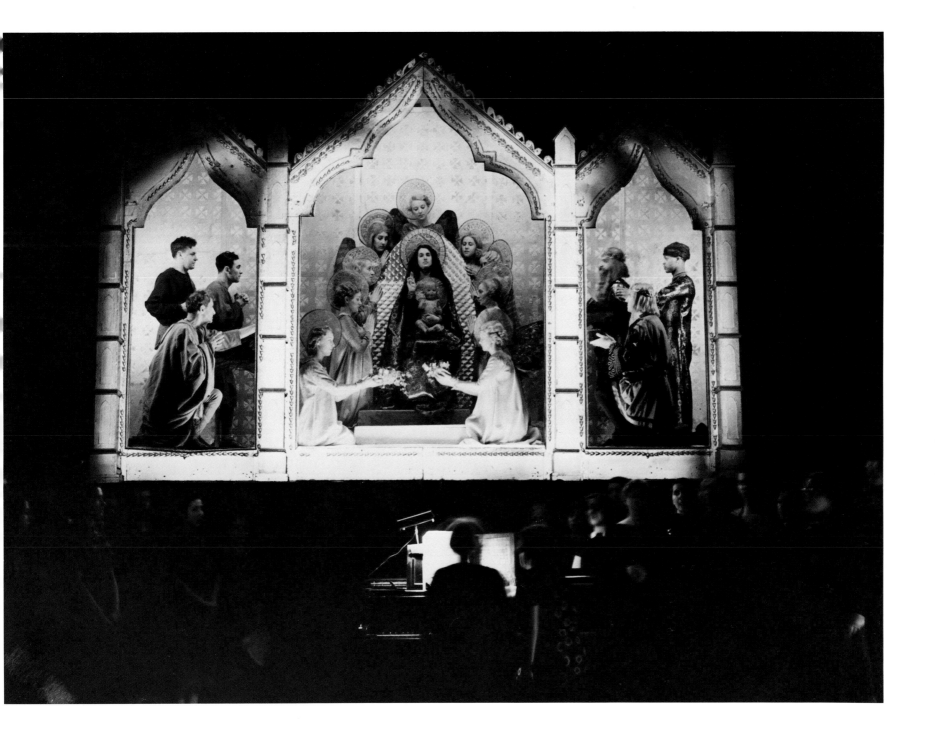

41

A Saturday dance class in Bowen Hall. Neighborhood residents in several age groups met each week at Hull-House for folk dancing and socializing. Called the Marionettes, the Mignonettes, the Pirouettes, the Harlequins, the Ballerinos, and the Punch and Judy Club, the members of these clubs had been together since early childhood and corresponded to Edith de Nancrede's dramatics groups.

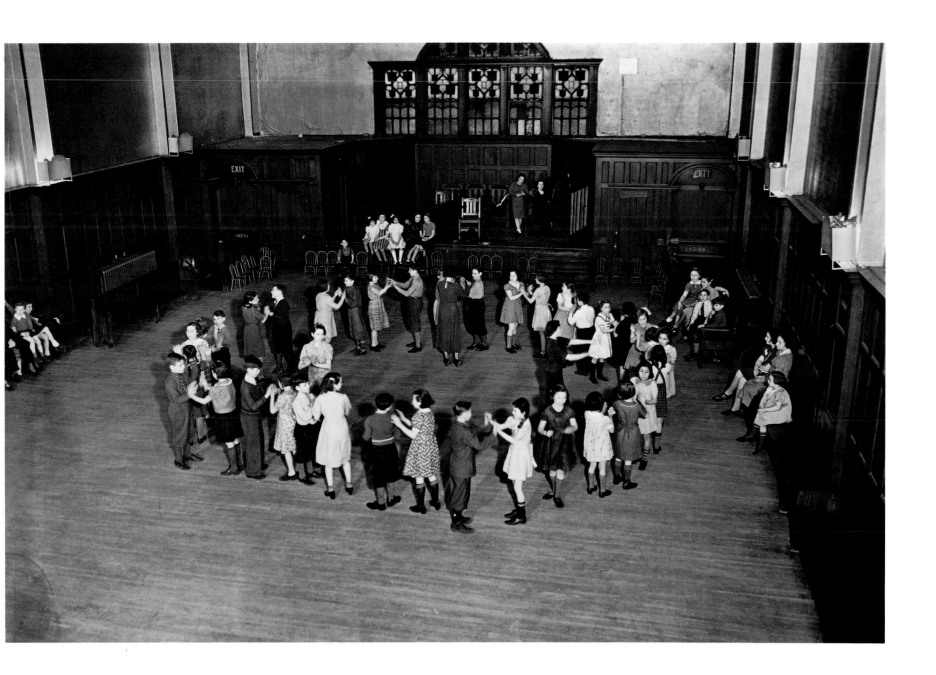

42

A citizenship class taught in the Hull-House Coffee House in the late 1920s. The 1906 naturalization law, requiring applicants to have real knowledge and preparation to receive citizenship papers, led to the establishment at Hull-House of free classes in naturalization and citizenship. The instructor, Jessie Binford, was also head of the Juvenile Protective Association at the time. The class members shown here are mainly Mexican men from the surrounding neighborhood.

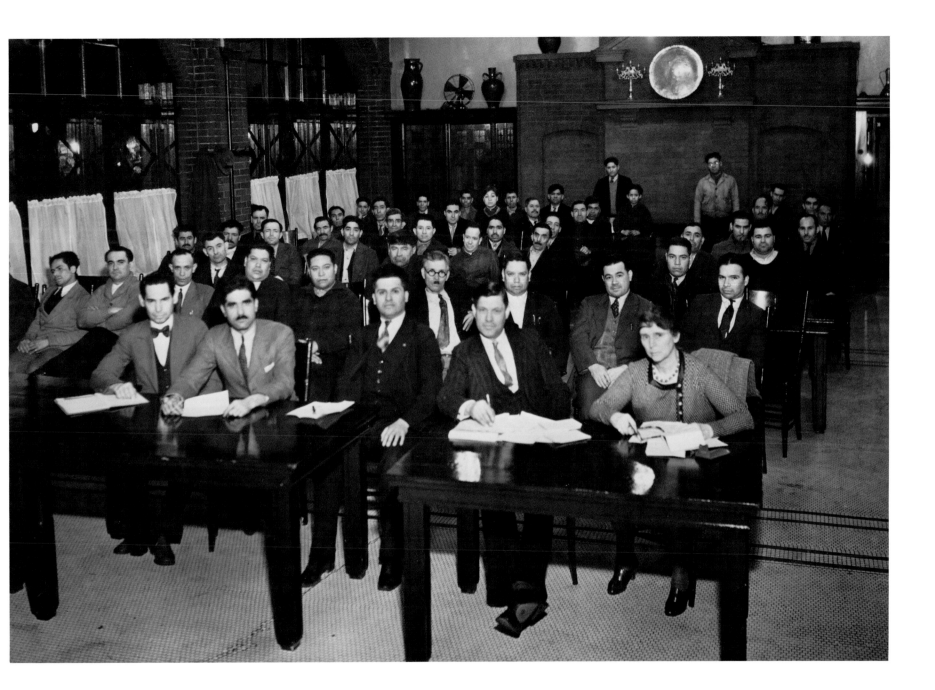

43

A typewriting class in the Indian Room, on the second floor of the Boys' Club Building. This room, decorated with genuine American Indian artifacts acquired by Jane Addams on a trip to the Southwest, was also used by small clubs for their meetings and socials.

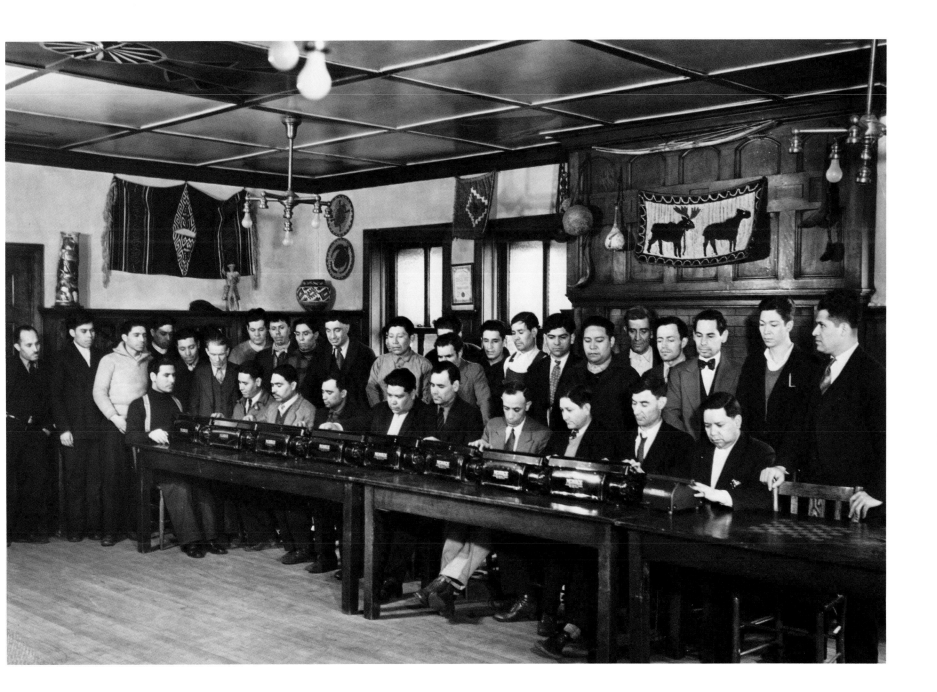

The Chicago Public Library maintained a children's
reading room at Hull-House. Part of a larger adult
library, this room was in constant use during after-school
hours. In addition to children's books, it contained a
small museum of toys from around the world, which was
said "to excite much interest and induce a wider range of
interest." The plaque on the wall reads, "Happy is the
child with books."

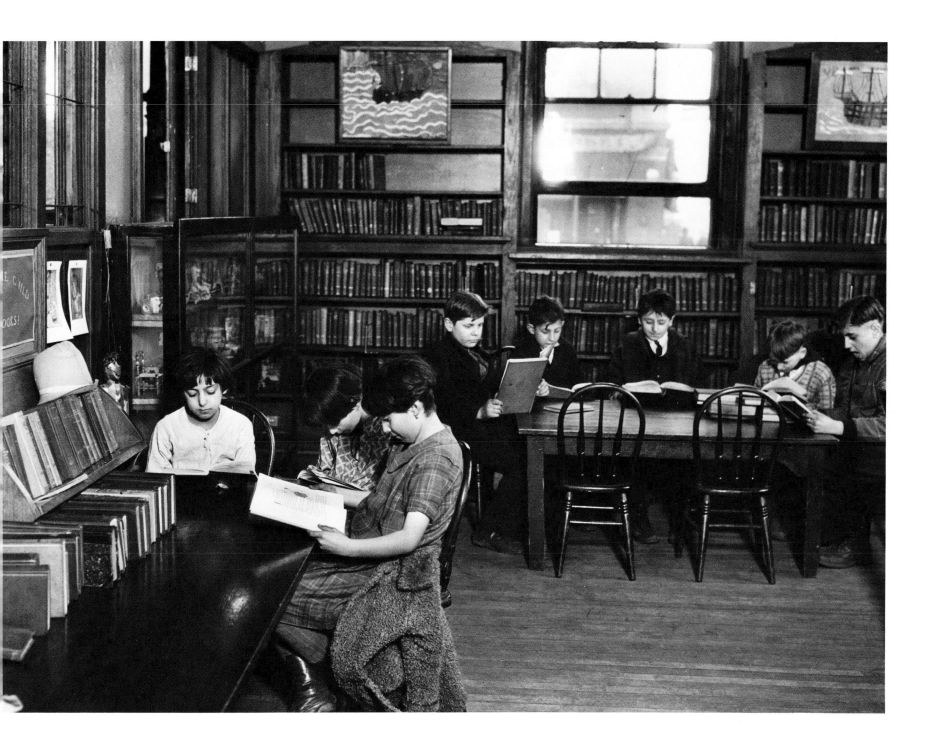

45

A resident's apartment in the Hull-House complex,
late 1920s. The staff actually lived at the settlement in
single rooms and two- to six-room apartments. This
photograph of a resident's apartment reveals pieces of
artwork probably made at Hull-House, a 1920s radio,
typewriter, camera, and copies of the *New Yorker*
and the *New Republic*.

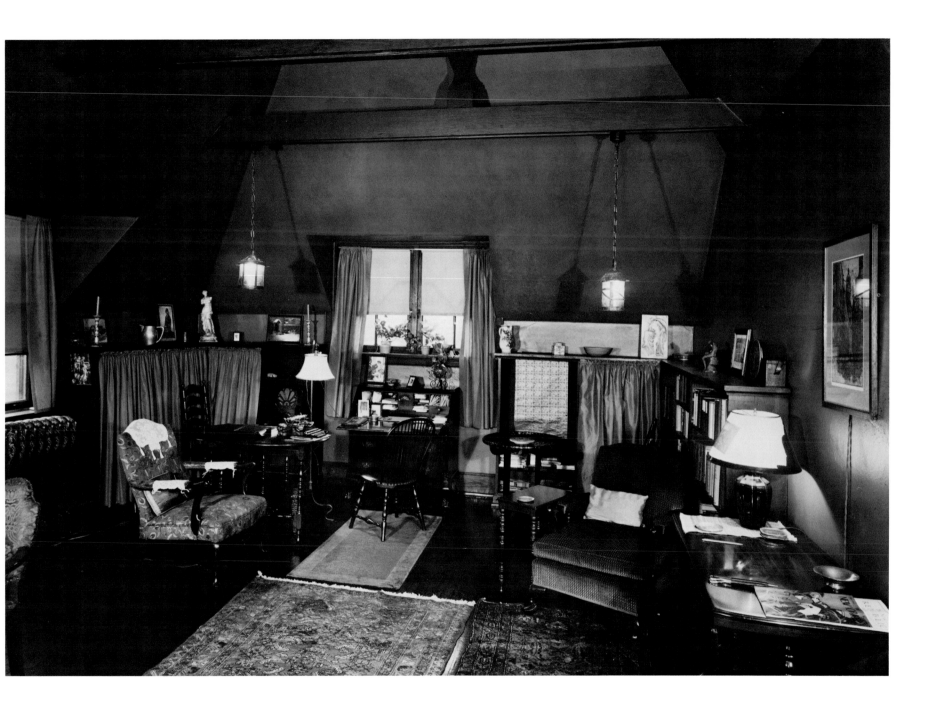

46

The Residents' Dining Hall at Hull-House, about 1930.
Every night, the staff gathered in this room for their
evening meal, which gave them an opportunity to discuss
the events of the day and be introduced to special visitors
to the settlement. Jane Addams is seated at the end of
the middle table; to her right are Dr. Alice Hamilton,
Robert Morss Lovett, Agnes Pillsbury, George Hooker,
and Victor Yarros. At the end of the front table is
Clara Stahl; to her right are Jessie Binford, Myrtle French,
and Enella Benedict. At the end of the back table is
Sadie Ellis Garland.

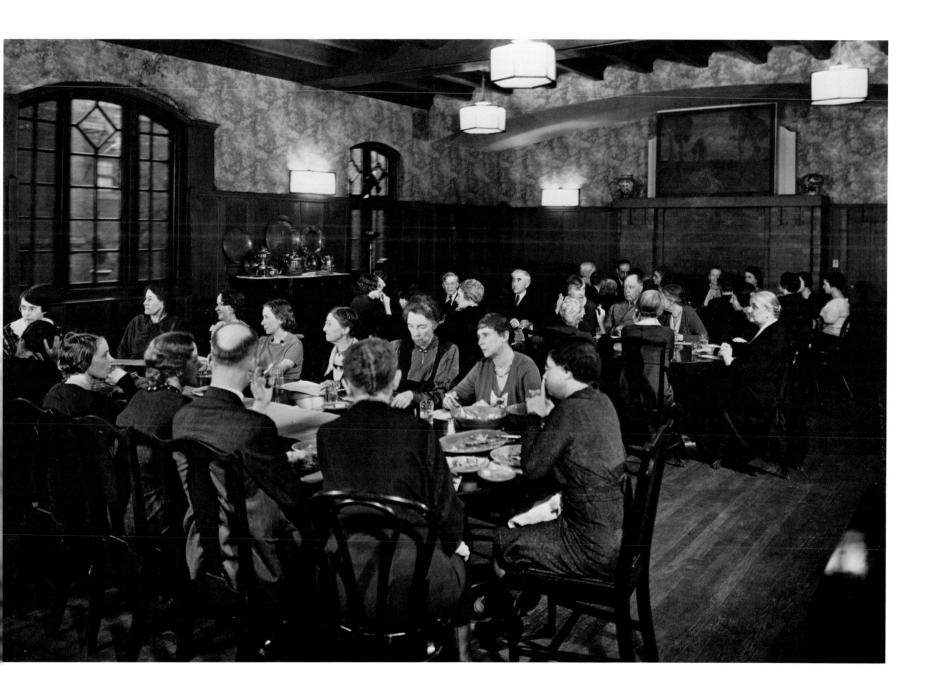

A corner of the southwest parlor on the first floor of the Hull Mansion, late 1920s. With the neighborhood activities of Hull-House conducted in the other twelve buildings, the first floor of the Hull Mansion became a quiet place for residents and visitors to gather for conversation and reflection. The painting above the bookcase on the far wall is by Carl Linden, an early Hull-House resident. Note the bottle-glass window treatment.

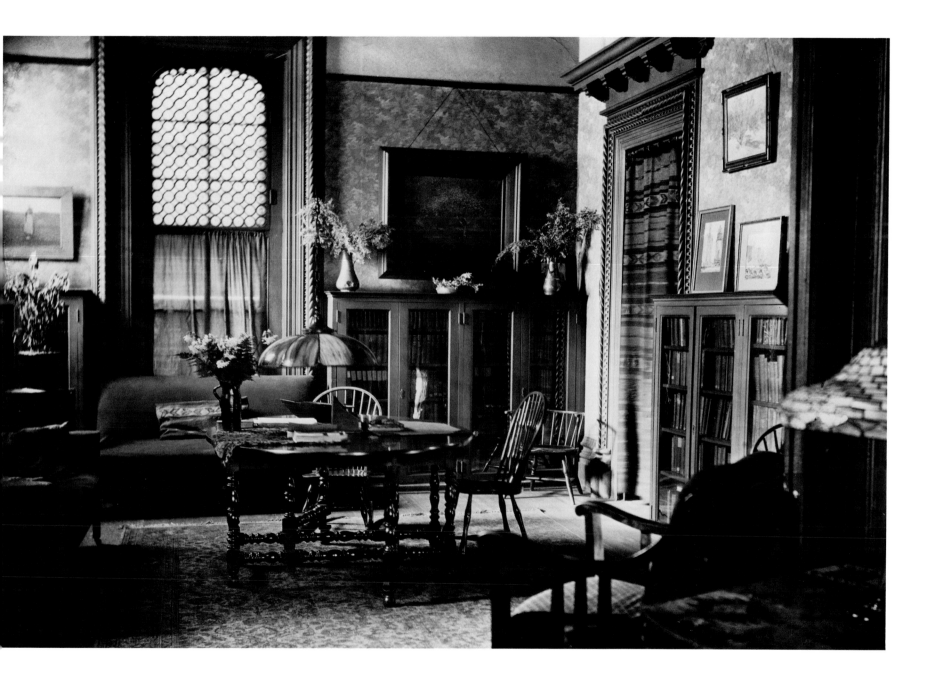

Neighborhood mothers and their children on the way to
the Mary Crane Nursery, early 1930s. This last structure
in the settlement complex, built in 1908 on Gilpin
Place, eventually housed all of the Hull-House activities
for very young children.

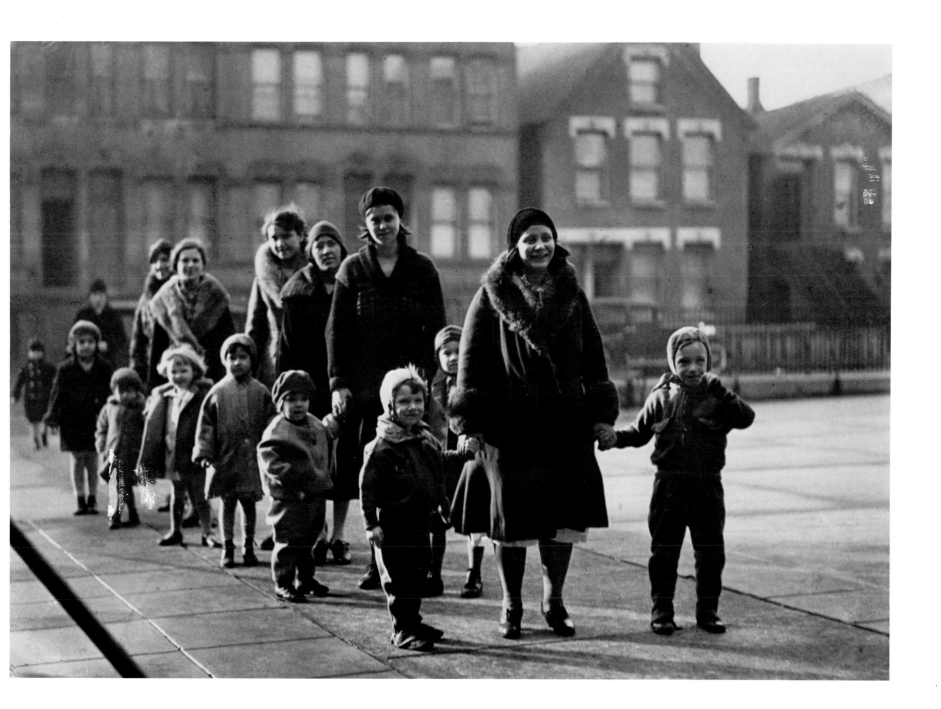

A view of the Mary Crane Nursery School. In 1925,
a demonstration center in preschool education was
established in the Mary Crane Building, staffed by faculty
from the National College of Education in Evanston.
Attempting to combine child and parental education, it
offered an all-day schedule for nursery school–age
children that included music, rhythm, painting, manual
arts and stories, recreation and outside play, physical care
and cleanliness, proper feeding, relaxation, and sleep.

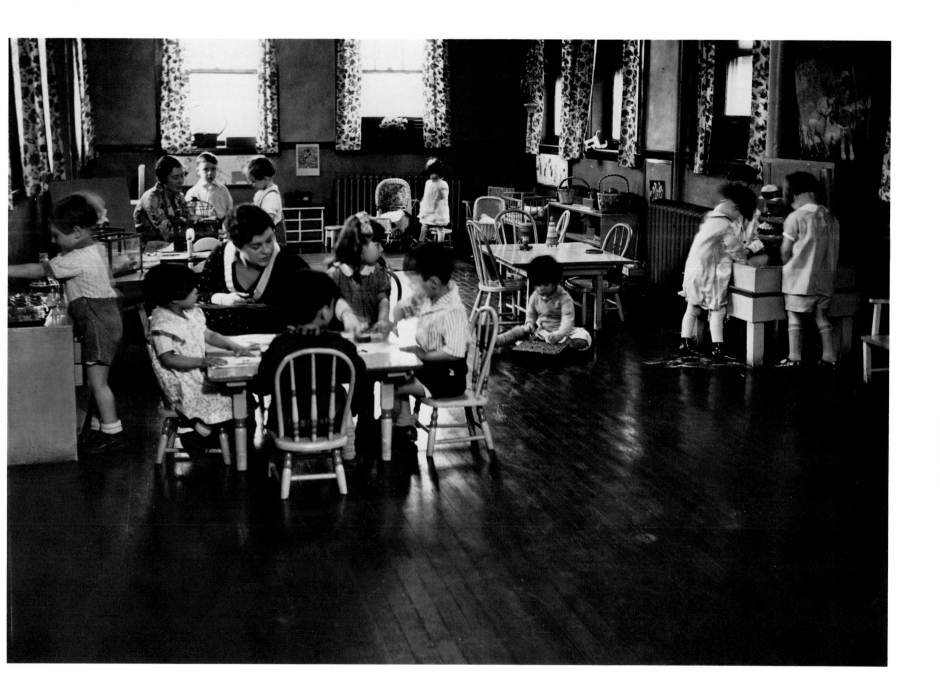

By 1930, at least five outside agencies cooperated with Hull-House to develop a comprehensive program of education and care for young children. One of these, the Infant Welfare Society of Chicago, provided child-care classes in the Mary Crane Building for mothers of infants under two years of age, as well as the services of an examining physician and a nutrition consultant.

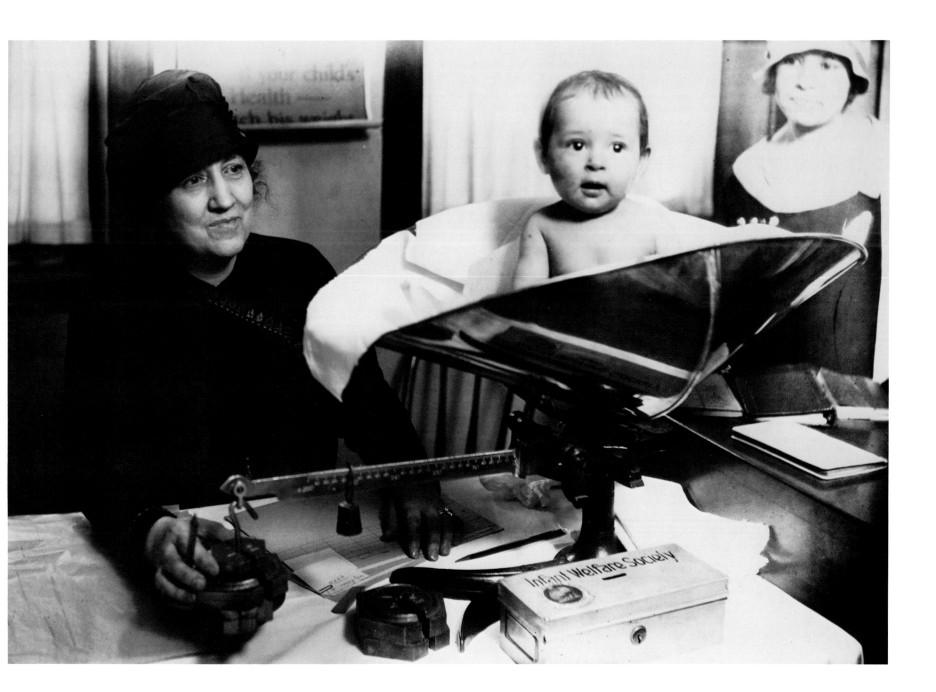

51

Bathing babies in the basement of the Mary Crane Building. The goal at Mary Crane was to unite the community in the effort to further the development of each child and provide for the needs of "the total child in the total situation."

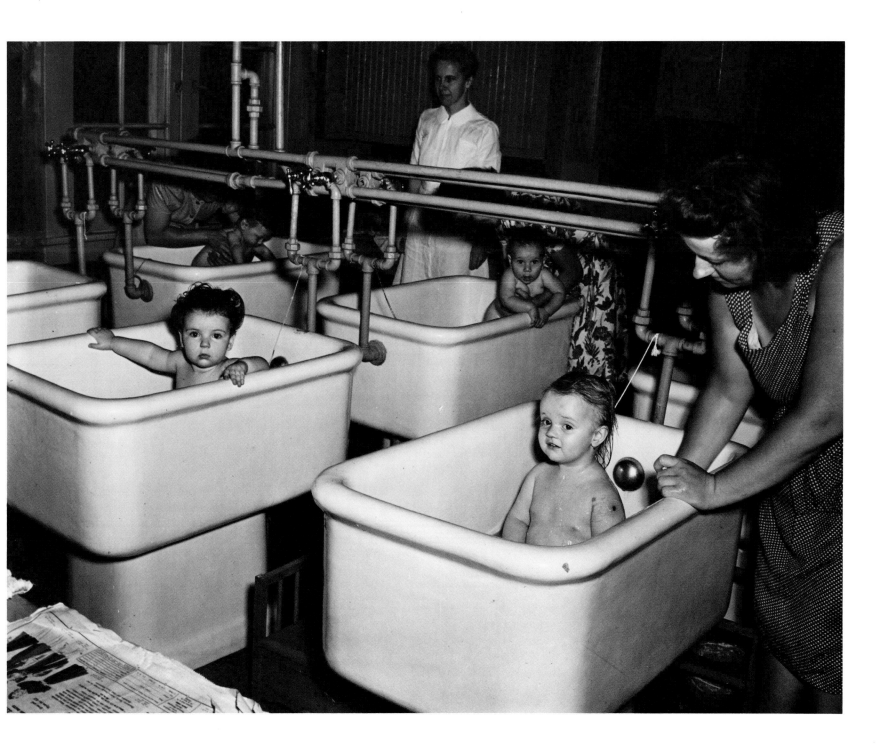

52

Storytelling at the Mary Crane Kindergarten, early 1930s.
Note the painting of Jane Addams in the upper right-
hand corner of the photograph.

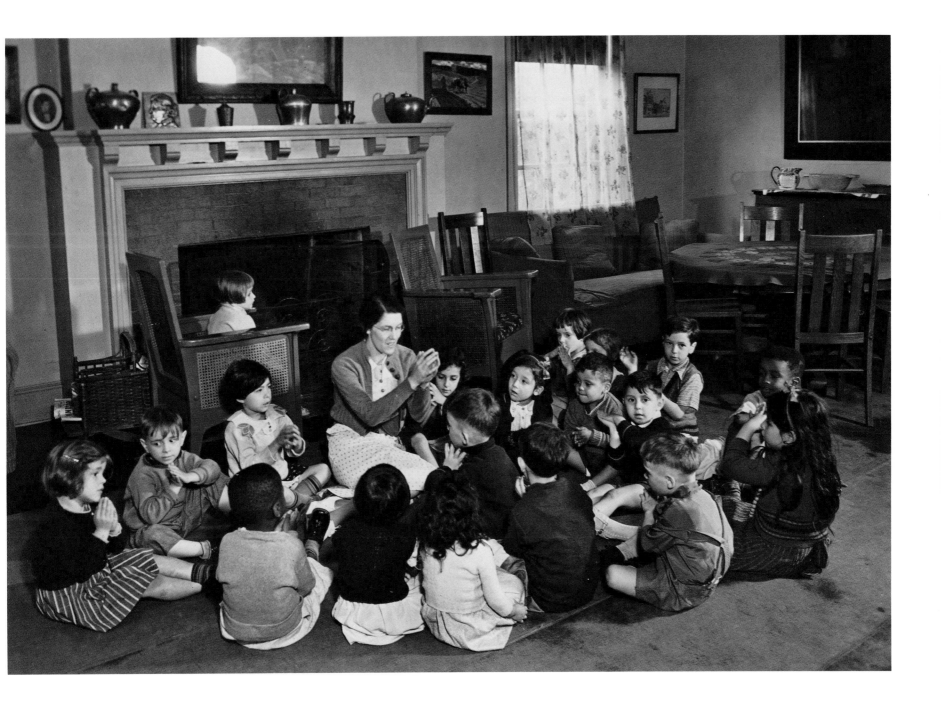

53

Jane Addams reading to children in the Mary Crane Nursery, early 1930s.

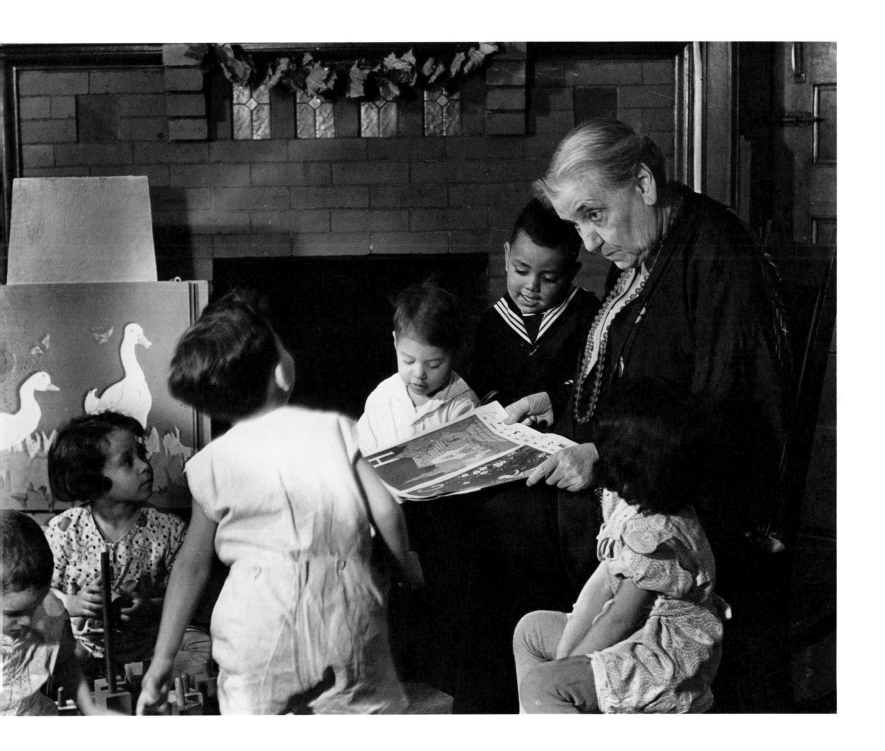

Waiting on Halsted Street to depart for Bowen Country
Club, a summer camp for neighborhood children and
mothers near Waukegan, Illinois. Bowen Country Club,
located on seventy-two acres of beautiful land overlooking
Lake Michigan, was donated to Hull-House in 1912 by
trustee and long-time friend Louise de Koven Bowen. By
the 1920s, it had become a second home for many of
Hull-House's group activities.

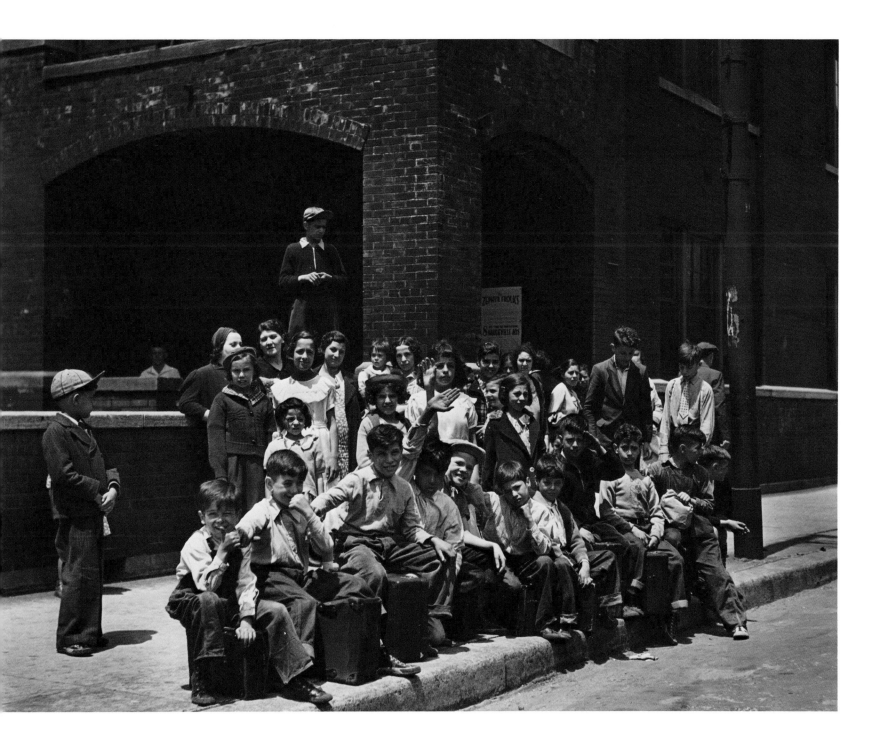

Two of the many buildings at Bowen Country Club.
On the left is the Commons, or dining room, where all
meals were served; on the right is Goodfellow Hall,
which provided space for dancing, skits, Sunday
afternoon meetings, and all group activities.

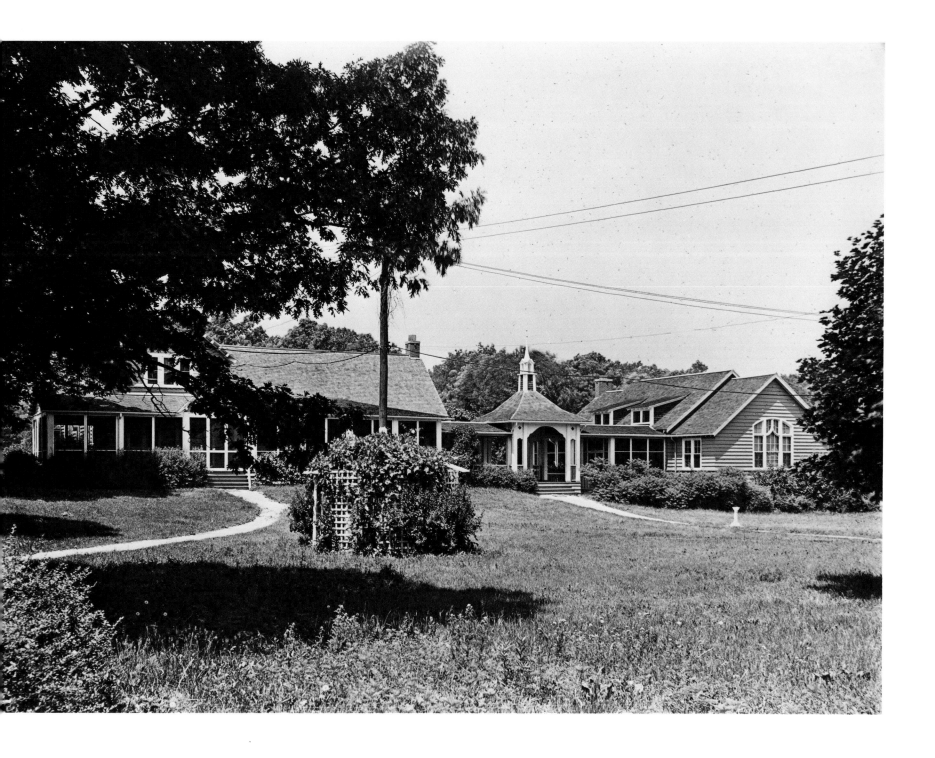

A sketching class in the formal flower garden at Bowen Country Club. Jane Addams and Louise Bowen both believed that city children, like those in the Hull-House neighborhood, "roughed it enough at home" and therefore deserved a chance to experience the beauty of nature in a safe, carefree setting. As a result, the Hull-House camp had a country club atmosphere, with beautifully cared-for grounds, nicely furnished buildings, and special touches of beauty everywhere.

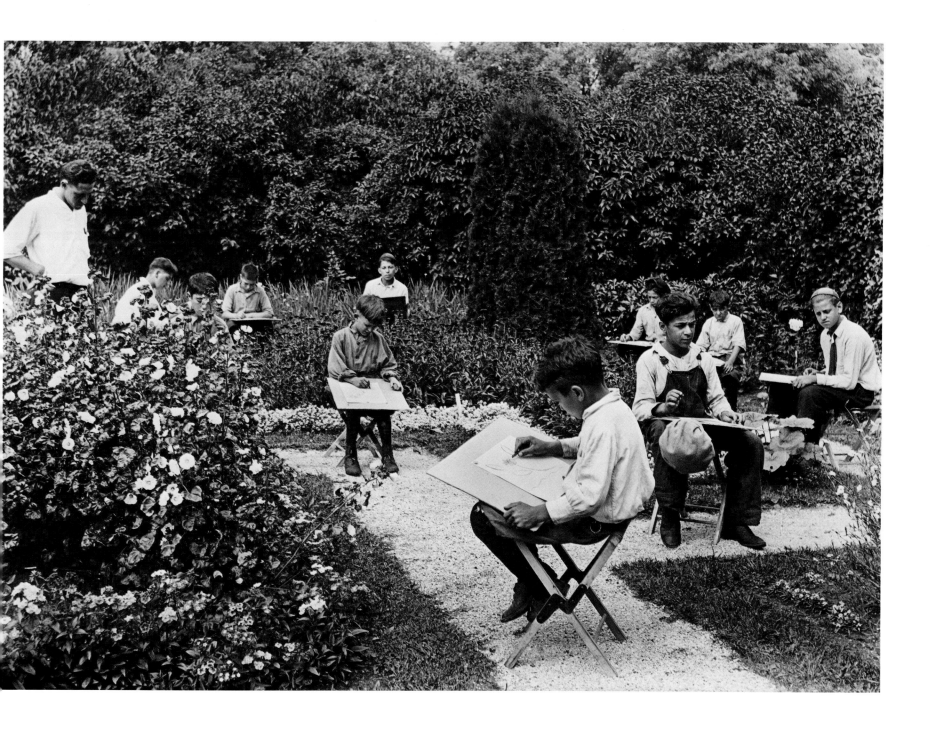

Young children at Bowen Country Club eat on the
Commons piazza at small tables especially designed for
them. As part of her endowment, Louise Bowen provided
for a permanent gardener to care for the grounds and see
to it that the camp overflowed each season with flowers,
fruits, and vegetables.

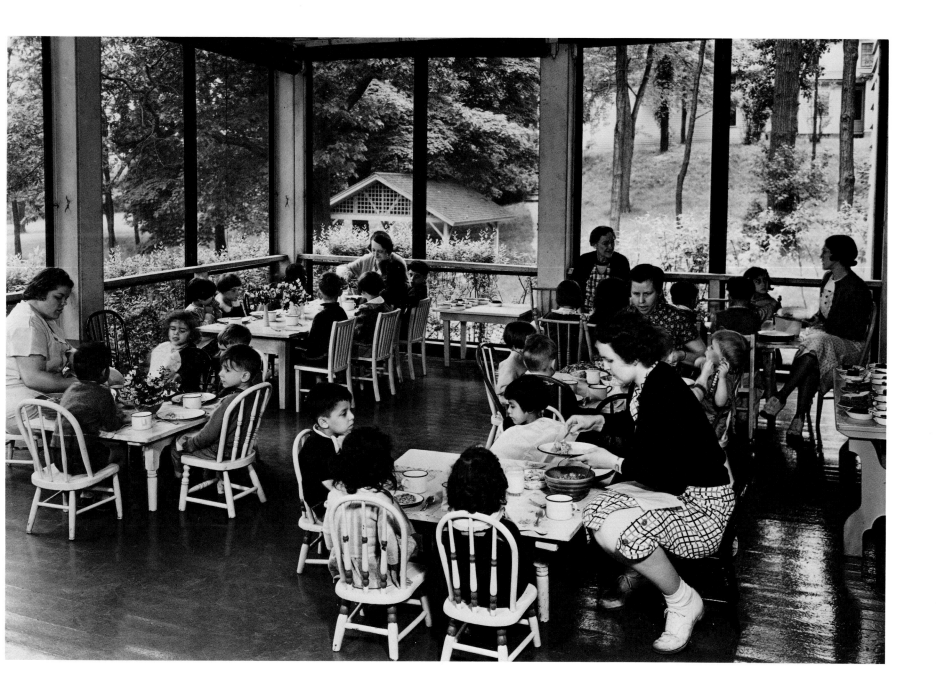

Mothers from the Hull-House neighborhood, whose inclusion was central to the program, relax at Bowen Country Club. They usually spent two weeks at camp each summer, living together in Rosenwald Cottage, pictured here.

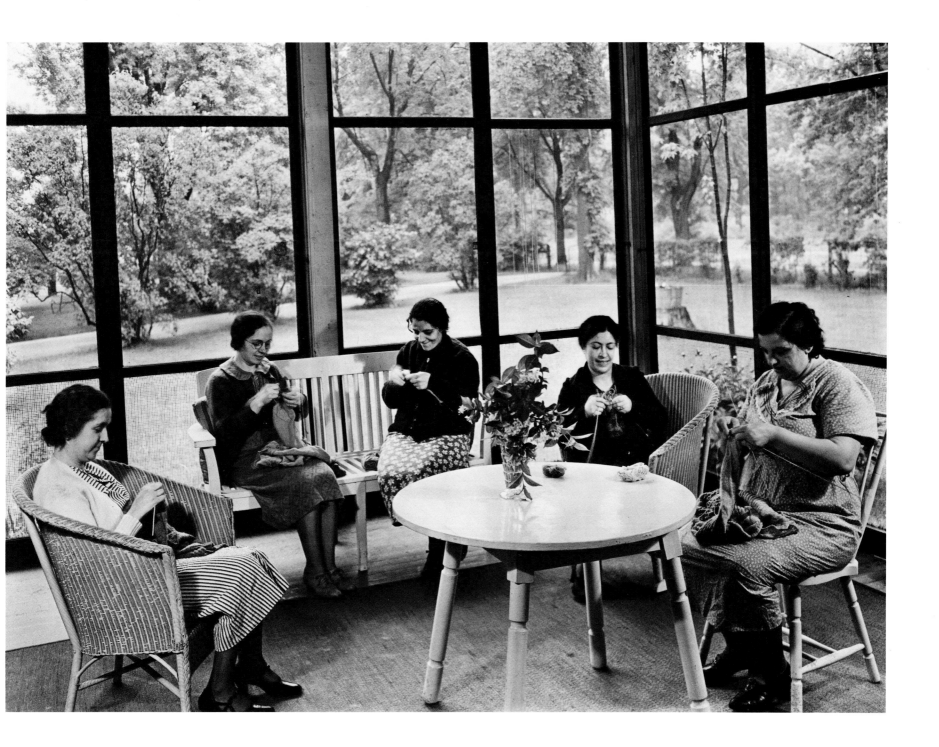

59

Lining up for Sunday evening supper at Bowen Country Club. The man with the sunglasses and hat is photographer Wallace Kirkland, who was also a camp counselor during the summer. Presumably, this is a self-timed exposure.

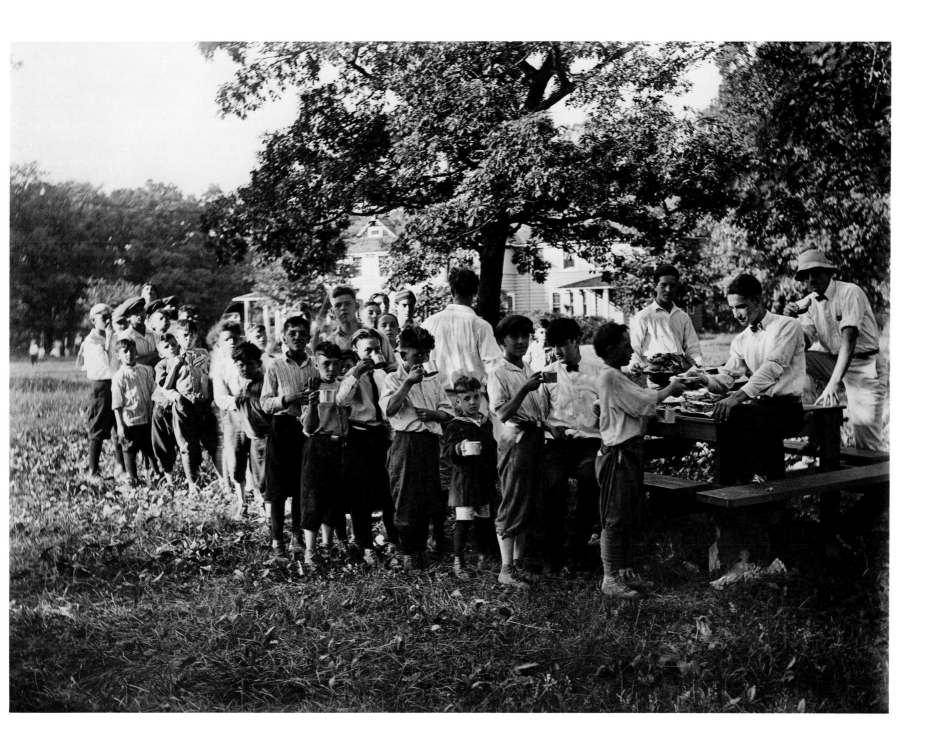

60

The Hull-House Boys' Band, under the direction of
James Sylvester, practiced under the trees at Bowen
Country Club. Every summer the band went to camp as
a group for two weeks of intensive musical training and
some fresh air.

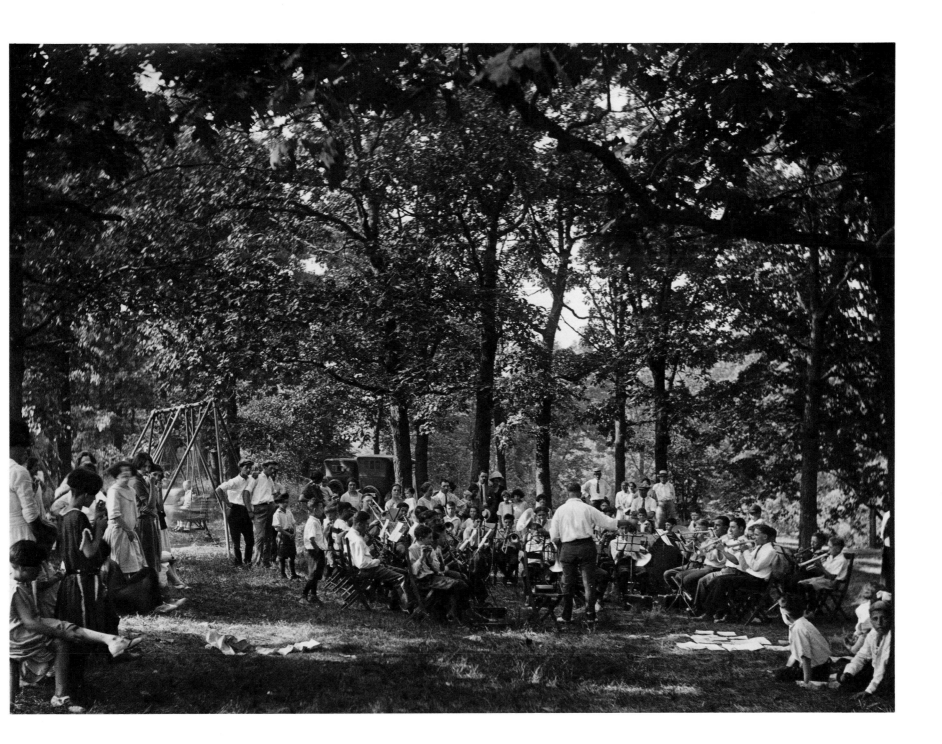

61

Members of the Mignonette Club at Bowen Country Club. By the 1930s, the Mignonette Club had been meeting at Hull-House for seventeen years, many of the members having joined the group when they were four or five years old. Edith de Nancrede's groups frequently went to Bowen Country Club to do theater productions in the summer and for special weekends during the rest of the year.

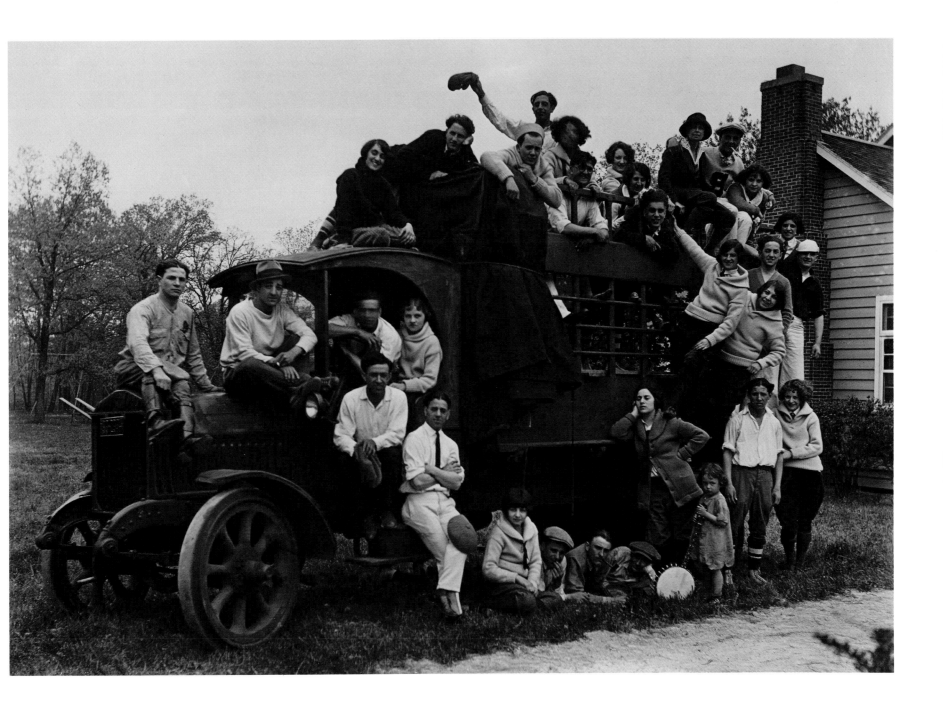

The funeral service for Jane Addams, May 23, 1935, in the Hull-House courtyard, with Hull-House residents occupying special places on the fire escapes and at the windows. Letters and telegrams of sympathy poured in from around the world. After the service, Jane Addams's body was taken to Cedarville, Illinois, the town where she was born, for burial.

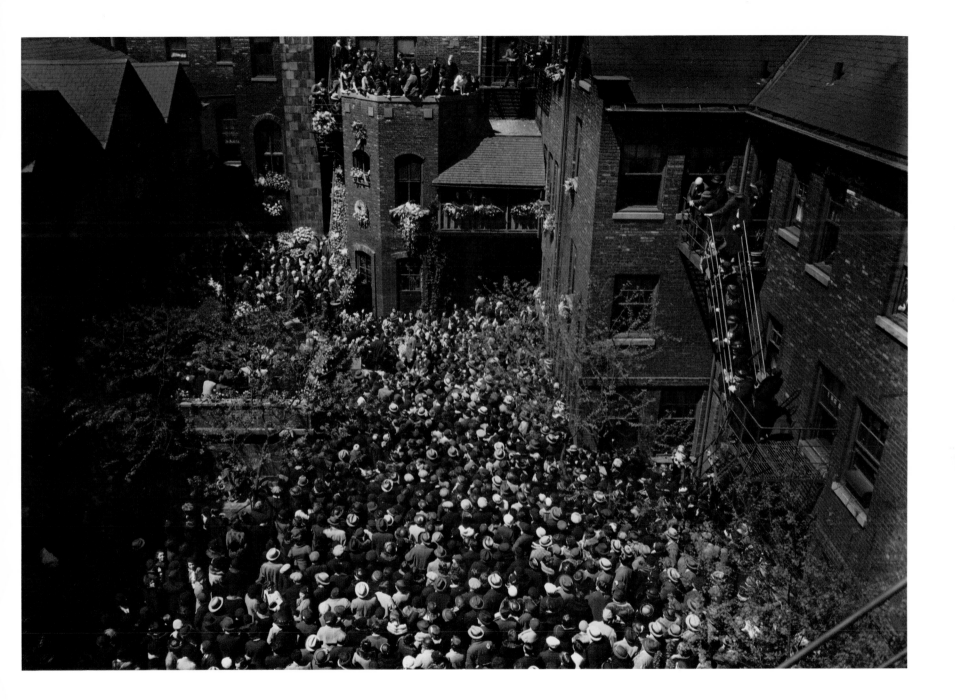

A NOTE ON THE EDITOR

Mary Ann Johnson is the director of the Jane Addams' Hull-House Museum at the University of Illinois at Chicago, where she is responsible for the operation and interpretation of the historic site through exhibits, tours, and other educational programs. A native of Chicago, she has directed numerous community-based public history projects and is particularly interested in the use of photographs to document and interpret the history of Chicago women, neighborhoods, and ethnic groups. She is co-author of *Walking with Women through Chicago History: Four Self-Guided Tours.*

BOOKS IN THE SERIES